Praise for the mysteries of Laura Crum

"Some finely drawn portraits, a tight plot that keeps its secrets until the end, and a spectacular assist from Mother Nature make for memorable reading."

— *Publishers Weekly* (on *Slickrock*)

"Fast-paced and filled with gripping action, it's a must-read for everyone who likes whodunits with horses in them."

— *Southwestern Horseman* (on *Hoofprints*)

"Descriptions of breathtaking natural surroundings abound, as do adept equine and human characterizations."

— *Library Journal* (on *Slickrock*)

"The pace is brisk and the reader becomes involved early on and travels at a high lope throughout…. Crum obviously knows horses and the industry."

— *Western Horseman* (on *Roughstock*)

"This first-rate mystery has everything: Crum's plot is sharp and satisfying, her setting beautifully rendered and her characters gritty and real."

— *RT Bookclub* (on *Forged*)

"Should delight fans of equine fiction as well as mystery lovers who enjoy reading about female protagonists who can stand on their own two feet—and do so proudly."

— *Washington Post* (on *Breakaway*)

"Read this for the lovely descriptions of horses and the happiness they bring people."

— *Rocky Mountain News* (on *Forged*)

THE GAIL McCARTHY MYSTERY SERIES
by Laura Crum

Cutter

Hoofprints

Roughstock

Roped

Slickrock

Breakaway

Hayburner

Forged

Moonblind

Moonblind

A Gail McCarthy Mystery

Laura Crum

[2006] PALO ALTO/MCKINLEYVILLE
PERSEVERANCE PRESS/JOHN DANIEL & COMPANY

This is a work of fiction. Characters, places, and events are the product of the author's imagination or are used fictitiously. Any resemblance to real people, companies, institutions, organizations, or incidents is entirely coincidental.

A PERSEVERANCE PRESS BOOK
Published by John Daniel & Company
A division of Daniel & Daniel, Publishers, Inc.
Post Office Box 2790
McKinleyville, California 95519
www.danielpublishing.com/perseverance

Distributed by SCB Distributors (800) 729-6423

Book design by Eric Larson, Studio E Books, Santa Barbara
www.studio-e-books.com

Cover design and illustration by Peter Thorpe

10 9 8 7 6 5 4 3 2 1

LIBRARY OF CONGRESS CATALOGING-IN-PUBLICATION DATA
Crum, Laura.
 Moonblind : a Gail McCarthy mystery / by Laura Crum.
 p. cm.
 ISBN 1-880284-90-1 (pbk. : alk. paper)
 1. McCarthy, Gail (Fictitious character)—Fiction. 2. Women veterinarians—
Fiction. 3. Pregnant women—Fiction. 4. Cousins—Fiction. 5. Stalking victims—
Fiction. 6. Horse farms—Fiction. 7. Santa Cruz County (Calif.)—Fiction.
I. Title.
 PS3553.R76M66 2006
 813'.54—dc22
 2006003857

This one is for Zachariah, my little boy,
with thanks for all the joy you've brought me

Thanks are also due to:

Meredith Phillips, my editor

Peter Thorpe, for the artwork
on this cover and many past covers

Craig Evans, DVM, for information
on moonblindness (all mistakes are mine, not his)

Ginny Uelmen, my patient sister-in-law,
for background on Thoroughbred racehorses
(hope I didn't get anything too drastically wrong)

And most important of all, thanks and much love to
Andy Snow, my very dear husband, for his love and
support, which made this book possible

] AUTHOR'S NOTE

Santa Cruz County is a real place, and the old Monterey Bay Ranch is based on a real ranch. Many details have been changed to fit the puposes of the story, however. All the human characters in this book are completely imaginary; most of the animal characters are drawn from life. To learn more about this mystery series, please visit www.lauracrum.com

Moonblind

Prologue

THE MAN WALKED QUIETLY down the dark barn aisle. Inside their stalls, horses rustled, snorted, sighed, and munched hay. Each small sound registered automatically in the man's ears—the normal, gentle noises of a barn at night.

Without hesitation, the human figure reached out for the latch of a stall halfway down the aisle. As he slid the bolt open, he peered into the dim interior, seeing the dark equine shape resting in one corner, a hind leg cocked.

Raising the halter he held, the man spoke in a low, calm voice. "Wake up, son."

The horse was already awake; its pricked ears were visible in the dusky light as it regarded the newcomer.

Moving with the natural assurance of a horseman, the man stepped toward the animal, patted its shoulder, pulled the halter over its nose and buckled it behind the ears, all without fuss. Stroking the beast's shoulder again, the man reached into his jacket pocket and produced a syringe.

In a moment, the cap was off the needle, and the needle

itself was removed from the syringe. Quickly and confidently, the man plinked the needle into the side of the horse's neck, with a motion much like throwing a dart. The horse started slightly, but the thing was expertly done, and the animal settled immediately as the man spoke to it and patted its shoulder again.

With the ease of long familiarity the syringe was re-attached to the needle, and the medication injected into the muscle. The man pulled the needle out smoothly, recapped it, and put the syringe back in his pocket. In another moment, the horse was free again, and the man was latching the stall door behind him, the halter casually draped over one arm.

The whole thing had taken maybe sixty seconds. But even as the man's footfalls receded down the dirt aisle, the reverberations were beginning. It would be years before they would die.

Chapter 1

THE PHONE RANG AT ELEVEN o'clock on Sunday night; I opened my eyes with a start. I wasn't on call, my sleepy brain protested, I wasn't even working days as a veterinarian, due to the seven months' pregnant belly rising like a mountain from my abdomen.

Grabbing the phone before it could ring again and wake my still-snoring husband, I whispered, "Hello?"

"Gail?" Jenny's voice.

"What's wrong?" I hissed.

"'I can barely hear you."

Still holding the receiver, I heaved myself out of bed and waddled into the other room. "What's going on?" I asked, all my antennae on the alert for trouble. Jenny knew better than to call me this late. These days, I was asleep by nine.

Nothing for a second, and then, "Boomer's dead."

I could feel my mind roving frantically. "Jenny, I'm sorry, but who's Boomer?"

"My dog. He's been poisoned. They killed him."

"Who killed him?" I demanded. "How do you know he was poisoned?"

I remembered Boomer now; a big yellow dog with a fierce bark and an easy wag, he'd been of no particular breed. Perhaps a Lab or shepherd cross, just generic dog. Jenny had gotten him from the pound about a month ago. He wasn't really a pet; he'd lived down at her barn as a watch dog, and was kept in a box stall at night.

Jenny was talking again. "I can't really explain. Something is going on. I found Boomer down at the barn—stone cold. He was poisoned." Suddenly she stopped. "What was that?"

Striving for a calm tone, I asked her, "What was what?"

More silence. Finally, "I keep hearing noises, like footsteps outside."

I stared at my own windows. It was February; a typical coastal California storm rocked the branches of the trees and spattered rain against the glass. Jenny lived a couple of miles away from me. Things were going bump in the night around here with monotonous regularity; what kind of odd noises could Jenny possibly hear over the storm?

"What kind of noises do you hear?" I asked.

"Boards creaking. Thumping, like someone's walking on the porch."

"Is this why you think the dog was poisoned?"

"Gail, he's dead. I just found him. Not a mark on him. He was poisoned," Jenny snapped, sounding more like her old self.

"I'm sorry," I said, abashed. "But what makes you think it was done on purpose? Maybe he ate some gopher grain."

Since Jenny had allowed the dog to run loose, and the neighbors were known to put out poisoned grain for gophers, I guessed this to be a more likely scenario.

"It wasn't an accident," Jenny said, as if she could read my mind.

Now this was strange. My cousin Jenny had never been one for histrionics of any kind; she was perhaps the most reliably levelheaded person I knew, with the possible exception of my husband, Blue. Her continued insistence that her dog had been purposefully poisoned was odd, and even odder coming from someone as sensible as Jenny. Surely the logical explanation for Boomer's death, if in fact he was poisoned, was an accident, not a canine murder.

"Jenny," I said, I hoped soothingly, "dogs do get poisoned that way. I never worked as a small-animal vet, but I've certainly heard lots of stories. And during my nine years as a horse vet, I ran into several cases of horses that were killed by eating gopher grain. Nobody meant for it to happen. I'm sure Boomer's death was an accident."

"He was killed," Jenny said flatly. "As a warning."

This was even more alarming. Jenny was simply not the type to imagine vendettas and/or stalkers.

"As a warning?" I repeated blankly. "Why?"

A long silence greeted this question. "There are some reasons," Jenny said finally, "that I can't tell you."

I took that in. "You're saying your dog was killed as a warning and you can't tell me why. That doesn't make much sense to me."

"Gail, you just don't understand." Jenny sounded

pathetic now, which was so unlike my normally hardhead-
ed cousin that I sat up a little straighter in my chair and
pressed the phone firmly to my ear.

"What don't I understand?" I asked.

"There are reasons," she said slowly, "why someone
might be stalking me. You don't know."

"So tell me. How can I understand if you don't
explain?"

A long, long silence. I listened to the storm lash at my
little house and waited.

Jenny's voice, when it came, sounded very small. "I'd
better not tell you. I promised I wouldn't tell anyone. If I
do, I just don't know what will happen."

Something in the tearful quality of the words caught
my attention. "Jenny, have you been drinking?"

Instantly she turned defensive. "Just a few drinks. Not
much. After I found Boomer."

"How many?"

"Three."

I said nothing. Three meant four or five, if I knew Jen-
ny. As I was now, in my current interesting condition, a
non-drinker, I was quick to recognize the gentle slurring
and easy emotionalism of the tipsy. No question in my
mind but that Jenny was just the slightest bit drunk.

"Jenny, I am so sorry about your dog. No matter how it
happened, I know how terrible it must have been to find
him dead. Is there anything I can do?"

Another long silence. Then, again, the very small
Jenny voice. "I'm just scared."

I took this in. My usually intrepid cousin, between shock and booze, sounded like a frightened four-year-old. I tried for a matter-of-fact tone. "Do you need help?"

Staring down at my pregnant belly, I hoped fiercely that Jenny would not ask me to come over. Not at almost midnight on a stormy night in my current condition. Hard-hearted as it sounded, I couldn't imagine dragging myself out at this moment in order to be a comforting hand-holder.

"It's all right," Jenny said at last. "I'll be fine. You stay home."

"Okay," I said firmly. "Turn the outside lights on, and have a look out at the porch. If you can't see anyone, then go to bed and try to sleep. If you see anything wrong, call nine-one-one and then call me back. And I'll come over in the morning first thing."

"Gail." Now Jenny sounded forlorn. "You're my cousin, my only family. I just moved out here six months ago; I don't have any friends. If you don't believe me, who am I supposed to turn to?"

"Jenny, I can't help you if you won't tell me the problem. You say someone's stalking you, but most of what you describe sounds pretty innocuous. The noises you hear are probably just the storm. And sad as it is about Boomer, I don't understand why you think someone's poisoned him on purpose. If you really feel threatened you should call the cops."

"If you don't believe me, why would they believe me?"

I was quite sure that, in fact, they wouldn't believe her.

"Jenny," I said again, "You need to tell me, or someone, why you think you're being stalked."

A lot of silence followed this comment. An elderberry branch tapped on my window; I hoped Jenny didn't have a similar bush near her house; she'd no doubt be convinced someone was right outside.

"Gail, when I was training racehorses back in Michigan, I knew some really scary people. People who were crooks. People who made other people disappear. Honest. The racetrack is a funny place. Really rich people, really poor people, scumbags and solid citizens, all rubbing shoulders. You wouldn't believe the stuff I've seen. And some of it, well, some of it could come back to haunt me."

This gave me pause. Jenny, along with her ex-husband, Charley Parker, had been training racehorses near Detroit for over twenty years. In the last six months, she and Charley had divorced, and Jenny had relocated near my home on the Monterey Bay in northern California. She'd purchased an old ranch with the money she'd gotten in the divorce and was running a lay-up facility for racehorses, doing quite well at it, by her own account.

I had been dismissing Jenny's fears as post-divorce and relocation stress, but suddenly I wondered. Thoroughbred racing was a foreign world to me, but I believed Jenny when she described it as an odd mix. An odd mix with a lot of money to be made. It was entirely possible that Jenny had witnessed some strange deals involving scary people.

"I really can't tell you any more. I'd be putting myself in danger, and you, too."

I took this in and thought about it. "Well, if you won't tell me, I don't see what I can do. At least not tonight. I'll come over tomorrow morning first thing and we can talk about it. Try to go to sleep. Call nine-one-one if you really think there's someone out there."

"All right." Jenny sounded subdued. "Please don't repeat what I told you to anyone, Gail. Not anyone."

"You didn't say much of anything," I pointed out. "See you tomorrow."

"All right." And I heard the click of her phone hanging up.

"Whew," I said out loud.

Now I was thoroughly awake—not much point in toddling right back to bed. I pushed my reluctant stomach up off the couch, walked across the room to the kitchen, and put the kettle on. Taking a box of peppermint tea out of the cupboard, I patted my belly gently as I felt the baby kick.

"Hey there," I said softly.

It was such an amazing thing. Here I was, thirty-nine years old, and pregnant for the first time in my life. Blue and I had married last June and two short months later, *voilà*. I had never imagined that it could be so easy at my advanced age.

Oh sure, we'd wanted a child, we'd hoped to get pregnant, we'd agreed to start trying. But neither one of us had dared to think it would happen this quickly.

It was definitely a shock. Having our dream turn so instantaneously to reality had left us both with cold feet, wondering if we'd made the right choice. But now, seven

months later, my attachment to our unborn child had grown as steadily as my belly swelled.

I talked to him, both out loud and in my mind, and I felt he answered me, as unreasonable as that might sound. Knowing that he was a boy, we'd named him already: McCarthy Winter, a combination of my last name and Blue's.

"So, Mac," I said out loud, as I poured hot water into my blue willow mug and sniffed the peppermint aroma, "what do you think? Is Jenny in trouble?"

The baby made no answer to this; perhaps such issues were not of interest to him. I settled myself on the couch and rested the mug gently on my belly. Immediately the baby kicked it.

I laughed. I knew this game. Moving the mug to a different spot, I waited a moment; he kicked it again.

"You like this, don't you?" I murmured as I took a sip of tea.

Giving Mac a new target to aim for, I gazed around the room in contentment. My home was endlessly satisfying to me, at all hours of the day and night. Sometimes I thought it looked its best, when, as now, it was illuminated only by lamplight and firelight.

This room, the main living space of the house, measured twenty feet by twenty feet, with another vertical twenty feet stretching up to the peak of the open-beam ceiling. The walls and ceiling were paneled with rough-sawn knotty pine, the floor was mahogany hardwood, and the little black woodstove chugged away on a gray stone

hearth in the corner. Big windows ran across the south side of the room and glass doors led out to the porch that overlooked the garden. All these panes were shiny black blanks at the moment, spattered with blowing raindrops.

The lack of external light only served to make the room seem cozier than usual. Orangey firelight flickered through the glass doors of the stove, and several freestanding and wall-mounted lamps made gentle pools of incandescent gold where they shone. I had resisted the urge to install overhead lighting, so instead of seeming harshly saturated, the room moved mysteriously from light to shadow, depending on where one looked.

Firelight glowed on the primitive wool rug that lay in the center of the room, a collage of old rose, amethyst, sand, and chocolate brown. A lamp shed a waterfall of brilliance on the dark green Navajo-patterned couch where I sat and illuminated the moss-colored armchair where Blue liked to read. Wall sconces lit up the round table in one corner and the desk and computer in the other. The long wall that formed the kitchen, with its terra-cotta tile counters and stainless steel appliances, was bright with track lighting that lit the working areas, but left the rest of the room dim and quiet.

I liked it this way. Most houses seemed to me to be jarringly brilliant at night, as though their residents wanted to deny the reality of the blackness outside the windows. My preference was for acknowledging darkness, sharing space with it, enjoying the intricate subtleties of its interplay with light.

Mac kicked accurately at my mug once again and I smiled, wondering what he would make of this little house that would be his home, too. Many people referred to it as my cabin, which in some ways seemed apt, as the entire house measured roughly seven hundred square feet. Besides the room where I sat, there was a bedroom and a bathroom/laundry room—that was it. "You'll be raising your kid in a one-room log cabin," Jenny had said with a grin.

"Not exactly," I protested. "It's shingled, and it has three whole rooms." But I knew what she meant. Was there really enough space here for three of us? Given that Blue and I firmly intended to let our baby sleep with us, as any right-minded mammals would do, the first year or so would probably work out, but then what?

"Guess we'll find out," I said out loud, whether to Mac or myself I wasn't sure.

Swallowing the last of my tea, I leveraged myself awkwardly out of the depths of the couch and lumbered across the room. "Time to get some sleep," I murmured.

But as I climbed back into bed with a still slumbering Blue, my mind drifted steadily back to Jenny. Jenny, my calm, competent cousin, and the oddly panicky tone in her voice. What in the hell was going on with Jenny?

Chapter 2

I AWOKE TO A CACOPHONY OF roosters. Roosters crowing from the treetops, from the chicken coop, from what sounded like the front porch. Close, anyway. Lots and lots of roosters.

"How many of the darn things do we have, anyway?" Blue muttered sleepily, as yet another one sounded off.

"About a dozen."

"That's eleven too many."

"You always said you liked the sound of roosters crowing at dawn," I rebutted.

"I said *a* rooster. Not twenty."

"We don't have twenty. At least, I don't think we do. I haven't counted lately."

"Close enough. Why don't we get rid of a few?"

"We're trying. Yesterday the Cooper's hawk got one. Last week the bobcat took another," I pointed out.

"I thought the bobcat took a hen."

"Oh yeah," I admitted. "That's right."

Unfortunate, but true; the predators all seemed to prefer hens to roosters. Smaller, more docile, less likely

to fight. We seemed to lose two or three hens to every one rooster.

"We could deport a few roosters," Blue said.

"You catch them, you can deport 'em," I agreed.

We grinned at each other. The flighty banties were quite difficult to grab; I knew we were both remembering Blue's last venture at rooster snagging, an unsuccessful attempt in all respects except that of entertainment value.

"Since you're now wide awake, thanks to our chicken herd, how about some tea?" I sat up in bed, doing my best to settle my belly comfortably in my lap.

"Yes, dear," Blue said with a grin.

The two dogs sleeping by our feet shifted themselves as Blue untangled himself from the bedclothes. Roey, the red Queensland heeler, settled back down along the length of my thigh; the oddly liver-spotted little white dog named Freckles yawned and stretched and wagged her plumey tail.

Blue climbed out of bed; I admired the long, straight stretch of his back and his flat muscled thighs. My husband stood six-six on his bare feet; every part of him was lean and stretchy, like the Thoroughbreds that Jenny trained.

Disappearing through the open doorway, Blue's naked silhouette padded away. In a moment I heard the sound of water running, the clink of the kettle, and the distinctive glug as the coffee maker switched on.

Coffee, I sighed. One more thing I'd given up since I'd become pregnant. Coffee got a mixed press from the

gurus of gestation, and I wasn't about to take any chances at the tender age of thirty-nine. I'd switched to tea, and kept it to one cup a day.

It was amazing, I reflected for a moment, how naturally these changes had come. I had felt no struggle, only the simple, singleminded urge to do everything possible to protect my unborn child. No coffee, no alcohol—no problem, despite the fact that I had very much enjoyed these substances throughout my adult life. Now, however, the overriding tide of my pregnancy seemed to sweep all before it.

Glancing out the uncurtained window, I saw that the storm had blown through overnight, rinsing the sky clean. Dawn glowed aquamarine and still as a pearl on the eastern horizon. On the bedside table, the little naked bronze figure of Pan lifted his pipes in the direction of the approaching sun.

I smiled. The statue had been our wedding present to each other: we'd found it in a dusty old antique shop in the tiny town of Moss Landing. The shop, a dark, cavernous barn, was filled with the usual motley assortment of junk; in one corner of a glass hutch Pan had been crowded round with china teacups. "Look at that," Blue had said.

The bronze figure turned out to have an exorbitant price; the storekeeper, a pale-skinned fellow who smoked endless cigarettes, had been unapologetic. No, he didn't know where it came from, or why he supposed it to be worth hundreds of dollars. He liked it; he didn't care if he sold it.

We both stared at the foot-high object in Blue's hands. Sinuous, naked and dancing, pipes raised high, this embodiment of Pan was a barely adolescent boy with a saturnine, wolflike face and the obligatory hairy goat legs and cloven hooves. Something in his graceful curved back and the smooth feel of his bronze shoulders was deeply appealing.

"I've always like representations of Pan," Blue said.

"I like this," I spoke at the same moment.

"It could be our wedding present," Blue offered.

And so it was done. Pan danced on our bedside table from then on, symbol of wildness and fecundity, god of the woods and all hooved and horned animals. When I found I was pregnant only a few short weeks later, I was sure that Pan had been partly responsible.

Blue's tall, wide-shouldered frame filled the doorway, red-gold curls backlit by the dawn into a veritable halo, or, as he put it, the full Einstein, bearing tea for me and coffee for himself. We had barely settled ourselves on the bed, pillows behind our backs, my blue willow–patterned mug resting on the convenient platform of my enormous bulge when Blue whispered, "Gail, look."

I followed the direction of his eyes and peered out the window, to see a young bobcat standing in the grass just a few feet from the house, staring curiously about. Centered in the window frame, surrounded by green grass and brush and backed by the just flushing sky, he seemed unreal, a vision, or a flamboyant nature painting. I could see the spots on his creamy belly fur and observe the delicate

twitch of his long whiskers; the white flag of fur on the underside of his short stump of a tail jerked sharply as he sniffed the air.

For a long second or two he stood there and stared; motionless, Blue and I stared back. Then, aware that something was not as it should be, the bobcat turned and vanished into the brush.

"Wow, I've seldom seen one that close," I said.

Blue agreed, and for a while we swapped bobcat stories. The wild cats were common in these hills, and relatively unafraid of people; everyone who lived in these parts could tell a tale or two.

We both thought that this particular bobcat must have been born last spring and was just now separating from his family of origin, which would account for the somewhat questioning expression, and the fact that he'd ventured up to the house. He was exploring, trying to find some territory of his own. I wished him much luck; Blue expressed a hope that his taste ran to roosters.

These creatures were continuing to sound off at regular intervals; fully awake by now, I climbed out of bed and began to pull my sweats on.

"I'll feed the horses, if you want to rest," Blue offered.

"Thanks, but I feel like getting outside. You can make breakfast if you want."

"Will do."

I shoved my feet into clogs and plodded out the door, still constantly surprised at how heavy and bulky I was, and at the curious way my belly preceded me everywhere

I went. The two dogs followed me, eager for a morning run.

It was a glorious morning: brown thrashers perched on the branches of the flowering white ceanothus bushes and serenaded me as if they were mockingbirds. Sunlight sparkled in last night's raindrops, spangled all over the green grass, and the air was sweet with the heady scent of the ceanothus and the yellow jonquils I'd planted along the path to the barn. Spring was definitely here.

A shrill nicker informed me that Plumber had spotted me; in another second Gunner's deeper voice chimed in. I listened—nothing else. Now that was odd. Danny usually nickered, too. Twister, my fourth horse, never did, just pawed the ground next to his feeder.

I hurried a little, and peered down the hill toward the barn and corrals. There they were; big, bright bay Gunner with his white socks and blaze; smaller cocoa brown Plumber, his ears pricked sharply forward as he craned his neck over the fence; dapple gray Twister parked next to his feeder, pawing the ground with an impatient front hoof. Where was Danny?

There, down at the end of his corral, under some oak trees, not even looking my way. I observed him with a worried eye. This was not normal behavior. Was he colicked, sick, injured?

The surest way to find out was to throw some hay into the feeders and see how he responded. I dished out alfalfa all around and waited.

Danny took note of what I was doing and ambled up

the hill in an interested way. He paused once, as if to catch his breath, which was odd, and he didn't approach his breakfast with any great eagerness, which was also unusual, but he did come and eat.

I looked him over closely, taking my time, but could see nothing obviously wrong. No cuts, no swellings—he hadn't appeared to be lame. He wasn't sweaty and he showed no signs of colic; still, I was aware that something was different.

Studying the dark bay gelding in consternation, I tried to decide what it was. Subtle, not obvious—a slight discomfort in his pose, a lack of brightness in his eyes. I'd been a horse vet for almost ten years now, and I knew the look of a horse that was a little "off." On top of this, I'd owned Danny for over three years, and this just wasn't quite normal Danny.

I sighed and stroked his cinnamon red neck and wished he could talk. "Is something wrong?" I murmured. "Can you tell me what it is?"

Danny flicked an ear and munched his hay in a steady if desultory way. I ran my eyes over him one more time and could detect nothing, except perhaps a slightly elevated respiration rate. Still, I was convinced that something was wrong. Unfortunately, I also knew from my years in the horse business that it could be a long way from this sort of intuitive recognition of a problem to a positive diagnosis.

Resolving to check on the horse during the day, I plodded back to the barn and poured some crumble for the

barn cats. One after another they appeared, my little feral cat family. First tabby Baxter, then coal black Jiji, and last fluffy little Woodrow. Their mother had disappeared last winter; I never knew whether a coyote had taken her or she'd simply departed for greener pastures. None of the cats was tame; I'd managed to trap them all and have them spayed and neutered respectively, and they showed up whenever they saw me and meowed to be fed, but they wouldn't allow me to touch them. They did, however, keep the barn free of rats and mice and had eliminated the ground squirrels that made deep holes in the horse corrals, and I was quite fond of them.

Next came the chickens; I threw handfuls of hen scratch and tried to count heads. It was rather difficult; my flock of banties had grown to outsized proportions and they scurried about so quickly I kept losing track. I'd started out several years ago with a pair, Jack the rooster and his mate, Little Red Hen, or Red for short, and now, as far as I could tell, I had a couple of dozen or so. Of which at least ten and quite possibly twelve, were certainly roosters.

I had no particular desire for this many chickens. But the banties nested in the brush and produced their broods, and despite predation from bobcats, coyotes, hawks, owls, and raccoons, to name only the primary culprits, the hens managed to raise a fair number of chicks, which were now mature chickens and crowing their heads off, to Blue's dismay.

I shrugged. Maybe the young bobcat we'd seen this morning would manage to grab a rooster before the day

was done. I just hoped it wouldn't be Jack; I was rather fond of the patriarch.

Casting another worried glance at Danny, who seemed to be peacefully munching, I trudged up the hill to the house, calling the dogs. Blue had made fried eggs and toasted English muffins with fresh-squeezed orange juice; as we ate, I told him my worries about the horse.

My husband listened quietly, as was his way. Blue was more of a horseman than I was and had been Danny's primary trainer and rider for the last couple of years. After taking in the story he asked me, "He's not colicked?"

This was a logical question. Colic—any sort of digestive upset—is relatively common in horses, and by far the most frequent cause of equine fatalities. If a horse looks a little "off," it's wise to suspect colic.

"No, I don't think that's it," I told Blue. "He's not lying down, or rolling, or pawing the ground, and he's not dirty; there's no sign that he's been lying down recently. And he did come up to eat and he's not restless or obviously painful. He just looks, well, a little bit like he's out of breath," I said. "But he hasn't been running around; he's not sweaty."

"That's odd," Blue said, sounding as puzzled as I felt.

"I know. I'll check him out during the day, maybe longe him in circles a little, see if he trots sound. If something looks really wrong, I'll have Lucy out to help me."

"All right. What else is on your agenda?"

I sighed. "I need to visit Jenny this morning. She found her dog dead yesterday; she thinks he was poisoned. And she seems convinced she's being stalked."

"Oh no."

"Yeah. She called here at eleven o'clock last night."

"I never even heard the phone." Blue looked remorseful.

"It's okay. You need your sleep. And she's my cousin, after all. She's the closest thing I've got to a sister. And I completely understand her being upset about the dog. But her insisting he was poisoned, and this stalker thing; it was odd."

"Any chance she really does have a problem?" Blue asked guardedly.

"You mean like a real stalker? I wonder that, too. She mentions nefarious dealings on the racetrack, and hints that if she doesn't keep them secret she could be in danger, and I don't know what to think. She won't tell me enough for me to have any idea about it one way or the other. The only thing I know for sure is that she's upset, she just lost her dog, she's my cousin, and I need to go see her."

"Yeah," said Blue slowly. "If you did think someone was stalking her, what would you do?"

"Call the police, I guess. But it's such a nebulous sort of thing, I doubt the police would be any use. Or that they'd be much interested."

"That's what I was thinking," Blue said. "If there's anything I can do to help, just let me know. Otherwise I'd better get off to work. Spring is our busiest season."

"I know." I kissed him affectionately as he bent down. "All you farmers struggle in the spring."

"That right. Including those of us who are just dilettante farmers." Blue grinned. "Mere rose growers."

I laughed. "Oh, the cabbage and strawberry guys been taking digs at you down at the café, huh?"

"Got it in one," Blue said.

I smiled up at him. "Well, I, for one, prefer rose growers. Or at least this rose grower."

"That's good," Blue said and kissed me again, this time on the belly. "Take good care of your mama, Mac," he murmured. And with another peck on my cheek he was out the door.

Chapter 3

AN HOUR LATER I WAS DRIVING down the narrow
strip of paved road that led to New Moon Ranch. That was
what Jenny had named the place, anyway. Like most of
the locals, I still thought of it as the Monterey Bay Ranch,
a name it had borne for many generations.

Not for the first time I wondered how Jenny had come
up with the money to buy this place. Granted, the old
ranch had been chopped up over the years and all that
remained besides the barns and houses was a mere twenty
or so acres; still, in crowded Santa Cruz County, twenty
acres of intact pasture land was both highly unusual and
exorbitantly priced. On top of which, this was one of the
most spectacular parcels imaginable.

The old Monterey Bay Ranch sat on the bluffs over-
looking the bay, in an area south of Santa Cruz proper
that was still relatively unspoiled. A trail led down through
a ravine to a private stretch of beach. The pastures were
flat and sunny and rimmed with cypress and pine trees;
there were two large barns and numerous outbuildings;
and besides the old ranch house, where Jenny's foreman

resided, there was a newer house, built right on the cliff top, where my cousin herself lived.

Wide pastures glowed brilliantly green this sunny spring morning, dotted with the bay and black and chestnut shapes of Jenny's racehorse boarders. The plastic-board fences were so purely white they were blinding; Jenny had hired a crew to install brand-new fencing shortly after her arrival. Passing the left-hand turn that led to the barns, I waved to Juan, Jenny's foreman, who appeared to be giving directions to half a dozen gathered minions. I drove on, as the narrow road narrowed still farther, and rounded a shelter-belt of somber pine trees to pull up next to Jenny's new home.

Hidden from the rest of the ranch by the trees, the house astonished in its boldness. Or perhaps it wasn't the house so much as the site. Literally clinging to the cliff top, the natural wood tones of the building seemed to meld into the sandy earth, and all one noticed was the soaring roofline and the air of transparency. A wall of windows faced the bay, letting in an immensity of sea and sky that would have seemed overpowering, even if alluring, to me. A long, wide unfenced deck ran alongside the windows—no rails to break the view. Here Jenny sat and drank her cocktails and contemplated the ocean and her life, a not unappealing prospect, or so I would have guessed.

At the moment she seemed to be drinking coffee. I could see the distinctive sheen of my cousin's hair and recognized the particular motion of raising a steaming

cup to one's lips. I climbed slowly out of my truck and went to join her.

A few stairs took me onto the back porch; bypassing the door, I followed the deck around the house to the side that faced the ocean. Cool, clean, rain-washed air seemed to whirl around me in the dizzy turbulence of the nearby surf; seagulls screeched and swirled and the water dazzled my eyes—blue-green, heaving, translucent, brilliant with dancing white lights. I blinked and tried to focus on the foreground.

Jenny sat in a weathered wooden chair, white porcelain coffee cup in her hand, eyes looking out to sea, apparently unaware of my presence. "Jenny," I called.

She jumped, startling halfway up out of her chair and spilling her coffee.

"I'm sorry." I waddled her way as she settled back down again and noticed that the brief smile she gave me didn't reach her eyes.

"I didn't mean to scare you," I said, as I sat down beside her.

"No problem." In the pure, revealing light of morning, Jenny's face was well worn and somber. I studied her carefully, looking for hints of excessive anxiety or emotional instability, but could see nothing obvious. Jenny looked as she normally did, only sterner.

My cousin was not an especially pretty woman, but the word striking would certainly apply; her hair alone demanded that accolade. A strawberry blond of a particularly vivid shade, Jenny's waist-length hair was a shiny, brilliant

reddish gold, worn this morning in a long braid. Despite that fact that we were the same age, and unlike me, she showed no gray at all, at her temples or anywhere else. Her fair-skinned, lightly freckled face was typical of redheads; her blue-green eyes, straight nose, and wide mouth were characteristic of our family; and her somewhat hard-edged expression was undiluted Jenny.

We didn't look much alike, I reflected, despite the fact that our mothers had been sisters. We were both tall, and I had the same mouth, nose, and eyes, but there the resemblance ended. Where I was wide-shouldered and strongly built, Jenny was slender and willowy, and my olive skin and dark hair were the antithesis of her pale brilliance. When we were teenagers, my mother had once referred to me as Jenny's shadow, an apt enough description, though I hadn't relished it much.

Jenny had always dominated me with ease. In our youth, she was unquestionably the leader and I the follower, and she had stayed one step ahead of me throughout our adult lives, or so it seemed to me. Married and running a successful Thoroughbred racing stable when I was still single and struggling through vet school, well established in a large and fashionable country home on a farm in Michigan while I was beginning my veterinary career and barely able to make the payment on my humble cottage—Jenny was always someone to be admired and/or envied whenever I thought about her

Until now. Now, despite the sudden and somewhat startling acquisition of her New Moon Ranch, Jenny

seemed lost and at a loose end, not quite sure what to do with herself. Which was understandable, given the fact that she'd just ended a twenty-year marriage and moved halfway across the country. Not for the first time I wondered exactly how this had all come about. Jenny had always been extraordinarily reticent about her personal life.

"Jenny, I think we should talk," I ventured.

"I know." Jenny kept her eyes on the horizon as she spoke, fixed on that thin edge where sea met sky.

"Maybe you could start by telling me a little bit about how you ended up here, what led up to it all. You and Charley came to my wedding together, and then a month later you called me up, said you were divorcing and had bought a ranch out here. You never really said any more, and I didn't ask, but now…" I spread my hands in a shrug.

"I know," Jenny said again. "Now that I'm calling you up in the middle of the night, you want to know what's going on."

"This whole stalker thing has got me worried."

"Worried that I'm in danger, or worried that I'm losing my marbles?" Jenny looked right at me for the first time.

"Both," I said.

"I can't blame you." Jenny's eyes swiveled back to the immensity of sea and space before us. Endlessly moving and endlessly still—the view was addictive. I found myself looking outward as well, rather than at her.

"So," I said, as we watched the waves, "what led up to this?"

"I don't know where to begin. It all goes back so far. But I know I owe you some kind of explanation. What to leave in, what to leave out," Jenny murmured, as if to herself or the ocean.

"Did you and Charley know you were divorcing when you came out here to my wedding?" I asked.

"Yeah, we did. We had most of it settled by then. Charley was being a good sport about it all; I left him, you know."

"No, I didn't know."

"Well, I did. Not that he didn't have plenty of reason to leave me, after the whole thing with Don came out."

"Don?"

Jenny looked back at me again and I saw the maze of fine lines that wreathed the delicate skin around her eyes, the mark of a redhead who has spent long hours in the sun. "That's right," she said. "I had an affair."

"You did?" I felt blank.

"With Charley's best friend," Jenny went on. "Don is a racehorse trainer, too; he and Charley have been friends ever since they grew up together in Wisconsin. Don was in and out of our house and barn constantly; he and Charley were partners on a few horses."

"And you picked him to have an affair with?"

"Not very smart," Jenny agreed, her eyes drifting back over the beach. "But I didn't pick him in any logical way. Like they say, it just happened."

"How?" I asked. I was genuinely curious. As a newly-wed myself, I simply couldn't conceive of hopping into

bed with someone else, let alone my husband's best friend.

"Charley and I had been married for years and years. We didn't have any kids; I don't know if that made it harder or not. We were both so involved with the horses, neither of us felt motivated to raise kids. But maybe it would have drawn us together more," she said, with a glance at my belly. "Maybe not. I can't explain it. We just weren't that interested in each other sexually anymore. We never made love, not for years. I didn't think of myself as wanting sex, to be perfectly honest; I thought I'd just gotten past my sexual period. I wasn't at all on the lookout for a man.

"And then one day, out at the barn, Don and I were working on a mare with a crack in her hoof; she was a horse we were all partners on. Charley wasn't around. Don and I were both bent over her foot, in this box stall, and Don touched my hand. Just brushed it with his, maybe by accident, I don't know. But I felt it like an electric current, shooting up my arm. I was so surprised I stared right at him; Gail, he met my eyes and I swear, it was like some dumb romantic movie. I could see he felt that current, too. I had never, for one second, considered Don Chase as anything other than a friend and business partner, and all of a sudden I wondered what it would be like to kiss him."

"And did you?" I was totally engrossed in her story.

"Not then. I think we were both completely surprised. We didn't know what to do. But it didn't take long. After

that, Don was on my mind all the time; I'd think about him whenever I was alone; I'd imagine making love to him. When he came over to the house, I noticed that he touched me more. And I wanted him to."

The words were pouring rapidly out of Jenny, as if some long-held dam had burst and the pent-up water was finally rolling free.

"What about Charley?" I asked.

"Charley never noticed a thing," Jenny said. "I doubt he ever would have. You know Charley. He's always been a good guy, but he's not the sensitive, noticing sort. Besides, I don't think he saw me as particularly desirable, or as the type of woman who would be interested in an affair. Charley didn't really see me as a sexual being. He wasn't the least bit suspicious."

"So what happened?"

"Just what you would guess. Don and I arranged to be together more and more. We smiled into each other's eyes a lot; we laughed together and touched each other. And then one day I set up a trip for the two of us to go look at a horse for sale in Kentucky. An overnight trip."

"And Charley wasn't suspicious of that?"

"Not at all. Charley was running some horses in Chicago; he couldn't go. And I'd made trips of that sort with others before—potential buyers, business partners. It wasn't a big deal. Except to me and Don."

"Don't tell me—you hopped right into bed," I guessed.

"Not exactly. Gail, you have to remember that I hadn't had any romance of any sort in my life for years. Don

brought me roses, he bought me an expensive dinner with champagne, he looked into my eyes and toasted me, and he acted like he couldn't get enough of me. And then, on the balcony outside my hotel room, he finally kissed me."

"And then you hopped into bed."

"Believe it or not, we didn't. We must have spent hours out on that balcony necking—my lips were swollen the next day—but I just couldn't take the step. I think we both knew what a big deal it was, the beginning of the end of the life we knew.

"But the next day we couldn't keep our hands off each other. It was inevitable. I called Charley and told him we'd found some other horses to look at and Don called his wife with the same excuse."

"Don had a wife?" I interjected.

"Oh yeah. She comes into the story later."

"Anyway, let me guess. The next night you finally got together."

"That's right. After many protestations of mutual devotion, we finally climbed into the sack and it was the best sex I ever had. I remember looking over at Don's naked body and wondering how I ever got so lucky. That was the high point."

"All downhill after that?"

"Sort of. The sex was good for a long, long time and we stayed really passionate about each other, well, for years."

"Years?" I was amazed. "How long did it go on?"

"Seven years," Jenny said simply.

I almost choked. "You had an affair for seven years?"

"That's right. There didn't seem to be any reason to quit. We loved each other, or thought we did; we certainly loved making love. Neither of us was sleeping with our spouses so we had a big need."

"Why didn't you get divorced and marry each other?"

"That's a good question." Jenny's eyes, so like my own but lighter, rain-washed, with paler lashes and brows, stared straight at me without really seeing me. "We did talk about it. It just seemed too disruptive. Don was genuinely fond of Charley and we had even more horse projects together by then. And Don and Annie had teenage children; he hated to leave before they were grown. And, believe it or not, I didn't want to hurt Charley either. So we kept it a secret and screwed around for seven years."

"Wow," I said.

"Wow is right. It got harder and harder to do. If you've never had an affair, you just can't imagine how demeaning it gets. You do things you would have said were unimaginable, things straight out of a trashy novel, and there you are, actually doing them."

"Like what?"

"Like checking into a motel room in the middle of the day and leaving an hour later, after you've had a good screw. It doesn't sound like much, when I say it, but over time, it starts to erode you. All the constant lying, the secret phone calls when the spouses are gone, the meeting in big parking lots and leaving one car or another so you can drive off together to yet another cheap hotel, the

holding hands in the barn when Charley wasn't looking. It just starts to wear you down. Your self-esteem is nil."

"I believe it."

"Not to mention you're worried all the time, afraid you'll get caught. Somebody you know will just happen to see you walk into that shabby hotel, someone will tell one of your spouses. It doesn't make for a good life."

"So why'd you keep doing it?"

"I don't know exactly. Neither one of us seemed able to give it up. Even though, by the end, I was getting a little tired of Don. He had a big ego. I didn't feel in love with him anymore. But I didn't know how to let go."

"What happened?" I asked her.

"Annie figured it out. I still don't know exactly how. Maybe someone told her; maybe she caught Don in one too many lies. She accused him; she didn't believe him when he denied it. I think we were both surprised at how angry she was. The first thing she did was call Charley and tell him. The second thing she did was call me and threaten to kill me."

"She did? What did you do?"

"I just didn't have the heart to lie anymore. It had gone on for so long; I'd lied and sneaked around as much as I could stand. I told Charley it was true."

"And then the shit really hit the fan," I ventured.

"More or less. Charley might have gotten over it; I don't know, but Annie went off the deep end. Left Don and basically disappeared, nobody knew what was going on with her. Periodically she'd call me or Don and make

threats. As for me, I guess I had enough of the whole deal. Enough of Don, enough of lies, enough of the husband I'd cheated on, enough of that life. I wanted to start over, a clean slate; I wanted not to feel guilty. So I left."

I considered this for a while, sorting through all the new information, trying to decide what it meant. Finally I said, "This whole stalker thing. Do you think it's Annie?"

Jenny cast me a quick look. "Annie's back in Michigan," she said firmly, as if she'd rather talk of something else.

I was pursuing it. "Last night," I pointed out, "you hinted that somebody from the racetrack might be after you."

Once again, Jenny gave me that sideways look, like a wary filly. "Gail, maybe I'm just paranoid. I spent seven years looking over my shoulder; I'm afraid it's ingrained. Here I am, all the way out here in California and I keep worrying about my past coming back to haunt me. Maybe it's a habit."

"Well," I said, "that could be true; so, practically speaking, what do you want to do about it?"

"I want to forget about it," Jenny said firmly, setting down her coffee cup with a little rattle. She stood up and stretched. "I don't want to think about it anymore."

"All right by me," I agreed, mentally crossing my fingers that this resolve would last through the night.

Jenny grinned at me, looking a good deal more like the Jenny I was familiar with. "Come on, Gail, let's go look at some horses."

Chapter 4

SO WE LOOKED AT HORSES for a while, that time-honored pastime. Jenny showed me the broodmares she was foaling out; I whistled when I heard what they were worth. She could recount the racing history and pedigree of virtually every horse on her place, as well as tell me its likely value.

"Where do they come from?" I asked her.

"They're mostly horses who have run at the track, some from Golden Gate Fields and Bay Meadows, some from Santa Anita."

"How do you get them?"

"I know a lot of people in the business," she said simply. "Lay-up farms succeed or fail based on the level of care you can provide. I've got a good track record, so to speak, when it comes to taking care of horses."

"So why do people send their horses to a lay-up farm?"

"People who own racehorses aren't usually horse people. There's exceptions, of course. But mostly they're rich people who want, for some reason or other, to have a racehorse. Sometimes they think of it as an investment, more often it's something along the lines of fulfilling an old

dream or ambition. A lot of the time it's about ego. Suffice it to say that they haven't a clue about taking care of a horse, and no place to put one if they did."

"A boarding stable?" I ventured. "That's what the rest of the world does."

"Would you put a horse worth over a hundred thousand in a boarding stable?"

"Nope," I agreed.

"I take first-class care of the horses here; mostly they're racehorses who've been injured or have some kind of problem they need to heal up from; sometimes a trainer will decide that a horse just needs a break. And then there are the broodmares, who need a good place to have their babies. And we stand three stallions."

Jenny was leading me back toward her largest barn as she spoke, a covered arena with a row of box stalls along each side; the place was huge and exceedingly tidy. All the aisles were raked and sprinkled, the arena had a fresh coating of sand, box stalls were immaculate and bedded with sweet-smelling pine shavings. Every horse I saw was glossy and polished.

The neatness factor was downright unnatural. There wasn't one pile of horse manure to be seen in the entire barn, no ubiquitous cobwebs festooning the rafters, no dust, even. There were fire extinguishers mounted by every door and a clipboard outside each stall, giving, I supposed, information on the inmate.

I commented on the quality of the whole operation; Jenny smiled with pride. "Six months ago when I moved

in, this barn was just a hay shed with aisles for dairy cows; the stallion barn was a shed with a row of old box stalls. We've done a lot."

"You sure have," I acknowledged, and wondered once again where she'd come up with the astronomical amount such renovations cost. On top of the purchase price of the ranch, no less. "It must have cost a fortune," I ventured.

"Bingo helped," Jenny replied absently, staring at a bay horse in the stall before us.

Long, lean, and stretchy, like most of the Thoroughbreds I'd seen today, the bay was otherwise unremarkable. No white markings, a fairly common head, a bit more bone than most of his kindred.

"This one is a gelding?" I asked, looking at him.

"Yep." Jenny stroked the horse's neck as he thrust his face toward her over the lower half of the stall door. "Bingo Boy's his name. He's the highest money winner of any Michigan-bred horse ever."

"Is that a big deal?"

"In Michigan it is." Jenny grinned. "Near Detroit, where we trained, Bingo here was quite the star. And he did win a fair chunk of change in his racing career. Like just a few thousand short of one million dollars."

"Wow," I said, quite impressed.

"I bought him as a yearling," Jenny said fondly. "He's always been my horse. And he stayed sound and kept racing until he was ten. Racing and winning," she added.

"Is that considered old?" I was surprised. "I know team roping horses that are still performing and winning in their early twenties."

"Ten's pretty old for a racehorse," said Jenny, sounding equally surprised. "Most horses are retired from racing by the time they're six or seven. Mares and stallions often go off to the breeding barn when they're four. Geldings get sold to the hunter-jumper crowd, if they're still sound."

"Not Bingo, apparently." I stared into the gelding's alert brown eyes.

"No. As long as we kept winning, I kept running him. And he's still sound today. He just got slowed down enough that he couldn't beat 'em anymore, and I didn't want to humiliate him. He's been a good horse." Jenny rubbed the bay's forehead. "He and Sunday are the only horses I brought with me to California."

"Who's Sunday?" I asked.

Jenny pointed at the next stall, and we both peered inside. The horse that faced the doorway was white, though his dark muzzle indicated he'd once been gray. His ears went up at our approach, but one glance at his milky blue, opaque eyes told me he was blind.

"Moonblindness?" I asked Jenny.

"That's right." Jenny looked down as she spoke.

"How long has he been blind?"

"About five years now."

"Wow. And you kept him all these years as a blind horse? Most people would have put him down."

"Sunday's special." Jenny rubbed the white forehead. "He was my first horse. I got him when he was just two."

"How old is he now?"

"Thirty-two."

"I don't believe it." I stared at the gray horse, who did,

indeed, look old, but hardly that old. I would have guessed twenty. The animal's back was only very slightly swayed, his muscle tone looked pretty good, his hipbones didn't stick out. "Are you sure he's thirty-two?"

"I've got his papers," Jenny said. "He's a registered Quarter Horse. Sunday's Child is his name. I used him as a pony horse at the racetrack for years and years. That was how I met Charley. He was training there in Detroit and hired me to pony his racehorses to the post. That's a long time ago, now."

"He was a gray?" I asked, looking at Sunday.

"Yep. He was a dapple gray when he was young."

"So I guessed," I said. "I've got one of those," I added, thinking of Mr. Twister. "He'll probably be white like this some day, if he lives so long."

Sunday thrust his head over the lower half of the stall door; I reached out and placed my hand on his neck a little hesitantly, but he didn't spook or seem surprised.

Jenny noticed my caution and smiled. "He's real used to being blind," she said. "He doesn't startle easily. He knows you're there because he can hear you talking, so your hand on his neck isn't unexpected."

"Is he hard to manage?" I asked curiously. "I've never known anyone who kept a blind horse."

"I've learned how to deal with him," Jenny said. "He relies on his hearing a lot. If you turn him loose in the arena to run around, you can see that he hears the dirt clods hit the walls and he knows where they are and stops in time."

"Does he ever run into things?"

"Oh yeah. Happens a lot. New places are really hard for

him. He sort of memorizes familiar things and knows where they are; he had a terrible time bumping into stuff when he first came out here. Bingo helps him. They're buddies, have been for years, and I always turn them out together. Bingo stays between Sunday and the fence, herds him away from obstacles. And Sunday follows Bingo's lead; he knows that Bingo's trying to guide him."

"Amazing," I said.

Jenny rubbed Sunday between the eyes and the horse leaned his head on her shoulder. "He listens to me, too," Jenny said, "don't you, boy? If he's about to run into something, I can shout, 'Whoa' at him, even across a field, and he'll stop. He's learned to trust me."

"What happens when he's walking across the pasture and he has to step over a log?" I asked.

"If it's something new to him, he'll use his front feet like hands, reach out and touch the obstacle until he's got an idea how big it is."

"Amazing," I said again. "You must be really fond of him."

"Yeah, I am," Jenny admitted. "I don't make pets out of most of 'em, but Sunday's special to me."

"It's a shame he went moonblind," I said. "That's such a weird disease. We still don't really know what causes it. Periodic opthalmia. Sometimes it comes and goes, though not in Sunday's case, I guess. It's unpredictable."

Jenny shrugged and looked away.

"People called it moonblindness because they used to think it was caused by the full moon. A horse would come down with it and then mysteriously clear up, and no one

could think of a reason for it other than the phases of the moon. To be honest, we still don't know a whole lot more than that."

Giving Sunday's neck a final stroke, I reached down and rubbed my own belly. "It's time for me to go home and fix myself and Mac a snack. Besides, I've got a horse of my own I'm keeping an eye on. He didn't seem quite right when I fed this morning, but I can't figure out what's wrong with him. I need to get back and have a look at him. As long as you're doing okay," I added.

"I'm fine." Jenny stared firmly at the ground.

I was not reassured, but could think of little else to do at the moment. "All right," I said. "Call me if you need me."

"I will," Jenny said absently.

She'd gone back to stroking her horse, and that was my last sight of her as I looked over my shoulder—a shining red-gold head bent forward and pressed forehead-to-forehead against the old white horse. Sunday stood perfectly still with his head against hers; I could have sworn that Jenny was seeking comfort, and that Sunday understood, and was providing it as well as he knew how.

I wasn't surprised. My own horses had done as much for me; I knew what a horse was capable of. But Jenny's pose was disturbingly dejected; something in her stance hinted at a distress that went deeper than anything she'd admitted to. I knew, without being told, that all was not right with my cousin.

Chapter 5

ALL WAS NOT RIGHT WITH DANNY, either. I went home to find the bay horse standing with his head down, his pose as suggestive of depression as Jenny's had been. Taking a halter off its peg on the barn wall, I walked out to catch him.

Danny put his head in the halter willingly enough; I led him up the short hill from the barn to the arena. Clucking to him, I encouraged him to trot around me in a circle. Danny knew how to longe; he broke into a trot, but came down to a walk in a minute, his sides heaving. I stared at him in consternation. Something was seriously wrong with Danny's respiration. A little bit of trotting should never have caused him to puff like this.

"Have you developed heaves?" I asked him, rubbing his forehead, as I pondered his laboring flanks. "Or bronchitis?"

Danny stood perfectly still, his head lowered to be stroked, his big dark eyes quiet and calm, despite his elevated breathing. He didn't appear to be in pain, just some sort of discomfort.

"I need help with this," I said out loud.

All my veterinary equipment was at the clinic, and in my current state, I didn't feel comfortable or safe doing the simplest procedures on a horse. I was going to find some reinforcements.

Leading Danny back down to the barn, I turned him loose in his corral with a promise to come back soon and hurried up to the house to eat a cheese sandwich. With Mac duly fed, I climbed back in my truck and headed out once again. So much for a quiet, restful day.

Santa Cruz Equine Practice looked much as usual when I drove in. A squat, gray, unimaginative building with roll-up garage-style doors, it had neither a horsey nor a friendly feel, something I'd always hoped to correct. However, Jim Leonard, the senior partner in the firm and my boss, was just as averse to spending money on cosmetic flourishes as he was to spending money in general. So far, my desires for renovation had been forestalled.

Someday, I promised myself, someday…though I had a feeling that day would be the day that Jim finally retired. Which was not today, or any day in the foreseeable future, now that I was out on maternity leave.

Jim and I had discussed it at length and agreed that I would take a year off, or more if I needed, during which time I would give up my salary, but not my benefits or my partnership interest in the firm. In order to cover my work-load, we would hire a third vet, and hope we would be able to generate enough business to keep all three of us employed once I was back at work.

And so Jim and I had proceeded to hire Lucy Conners, fresh out of vet school, all of twenty-five years old; young, pretty, and tough as nails. We'd both had our doubts, but something about Lucy was convincing, and she'd proven to be a trooper. Raised on a horse farm in Kentucky, Lucy had a strong intuitive sense for what was wrong with a horse; her clinical impressions were superb, and her mind was as sharp as a razor blade. Jim and I found ourselves asking her opinion on cases after she'd been with us a month; by the time I bowed out, three months later, we were comfortably convinced that Lucy was the best thing that could have happened to the practice.

She stepped out of the office just as I parked my truck in the back parking lot. Her quick glance in my direction shifted to a wide smile as I clambered awkwardly out of the cab.

"Gail, how are you? How's everything going?"

"Good. Mostly. The pregnancy's going fine, anyway." I said, knowing that was what she meant.

We smiled at each other with genuine liking, or at least, I was aware that that was what I felt for her. I'd always sensed that the feeling was mutual. Lucy's smile spread right into her eyes; I was struck again by what an appealing creature she was.

Slender to the point of appearing ethereal, Lucy had a deceptively fine-boned body that was unexpectedly strong. Her face was all planes and angles, her eyes huge, her mouth wide; some wonderful mix of races had given her classic café au lait skin; silky, crinkled black hair; and light

brown eyes with a tinge of green. All these elements combined in the most harmonious possible way with her sharp-edged mind and ready warmth. I stared at Lucy with my usual mix of appreciation and consternation.

What was it about these exceptionally pretty people? I tended to find myself with a tinge of automatic dismay, an impulse to assume that anyone so attractive could not possibly be competent and intelligent as well. In Lucy's case I knew this wasn't true, and yet the thought arose along with a simple recognition of her beauty, much as I admired a freshly opened tea rose in my garden.

"Is Jim here?" I asked, knowing he wouldn't be, not even sure I wanted him to be. Though a vastly more experienced vet, Jim was a lot harder to talk to than Lucy, and a good deal less sympathetic.

"Nope. He's out on calls." Lucy shrugged and rolled her eyes.

No surprise there. Our mutual boss was a real workaholic, and tended to expect the same of his subordinates.

"I've got a problem with one of my horses," I said, and recounted Danny's breathing difficulties. "I don't know what to think," I told her, "and I really need to have someone do a proper exam. I don't even have a stethoscope at home. Can you come out?"

"No problem. I've got three calls and then an opening. I can be at your place by, say, two o'clock."

"Thanks," I said. "I appreciate it. Are you on your way out now?"

"Yep. Got a colic up in Scotts Valley."

"I won't keep you. I'll just go on in and say hi to the crew."

"Oh yeah. They'll all be happy to see you. Everyone wants to know how you're doing." Lucy flashed that wide, engaging grin again, said, "See you later," and climbed into the vet truck.

I watched her drive out of the lot with an odd mix of emotions. Relief, nostalgia, jealousy, liking. It was hard to sort them all out. I was definitely relieved not to be dashing off to see yet another colic case; it seemed to me that at this point in my life I'd probably treated several hundred colicked horses and in my current state of permanent fatigue, not to mention enormous bulk, the idea of dashing anywhere was repugnant. Still, that was my old truck that Lucy was driving, that was my job she was doing. It did feel odd.

Dutifully, I marched into the office to show off my belly and receive good wishes. An hour later I was back home and sacked out on the porch with my feet up. I'd checked Danny when I drove in; he'd seemed exactly the same. Not miserable, not happy, breathing a little labored. I was mystified and exhausted.

Taking a long swig of water from the obligatory bottle at my elbow, another post-pregnancy development—staying hydrated being thought to be good for the uterus—I stared out over the garden. It was noon and a soft, sunny, seventy-two degrees, a perfect example of the lovely February weather that we sometimes got here in Santa Cruz County. I had two hours until Lucy was due and I intended

to do nothing, absolutely nothing but sit in this chair the whole time, with my two little dogs snoozing by my feet.

My book lay open and face down on the blue tiled table beside me, but for the moment I rejected it in favor of simply watching. Watching the plants, watching the sky, feeling a light breeze mingle with the sunshine on my skin. On impulse, I unbuttoned my denim shirt and took it off, exposing the enormous pale mound of my belly. I'd read that in the later stages of pregnancy, a fetus can see sunlight through his mother's skin.

"What does it look like to you, Mac?" I murmured. "A pink glow in your little world?"

I felt the baby stir gently, as if in answer, and I sighed in content. Mac was fine. It had become automatic, this constant monitoring of the baby's movements, this half-conscious checking to make sure he wasn't still too long.

I'd read all the literature, naturally, and though I tried not to live in a constant state of worry, some of the stories and examples of possible problems were indelibly printed on my mind. Things did go wrong, medical things, major things; my career as a horse vet had taught me only too much about this. And so I worried and monitored Mac's movements and agonized over every test that came back anything other than absolutely normal. I'd refused to do amniocentesis—it had simply seemed too invasive—and the other tests had been reassuring, but still, I worried.

Would Mac be okay, a healthy, normal baby? Or would he be in some way other than that? The possibilities were

endless; I could feel my jaw tighten as I scanned through them once again.

A finger of breeze rippled over my belly, and Mac moved gently, lazily. I took a deep breath. Right now, in this moment, all was well. And this moment was all I had.

Consciously, I put my attention on the garden, and re-laxed my muscles. Everything was green, that intense, golden green that is the very essence of spring. Short, bright grass clothed the slopes, and choked my neglected vegetable beds. No rose was in bloom except the persis-tent China named Mutabilis, but the rosemary plants that trailed down the hillside were covered with blossoms, pale sky blue through cobalt, depending on the variety. Narcis-sus were brilliant yellow, orange, and creamy white stars, dotting the grass, and the brushy hills that surrounded my property were thick with arching, cascading bushes of the wild white ceanothus, looking as though they were laden with snow and scenting the air with an intoxicating, un-earthly smell.

Life was good. The garden sang a constant song of praise and delight, and I was here to hear it. My eyes rest-ed on the little ornamental pond I'd built near the porch a few years ago. The water lilies were dormant now and the goldfish were hiding, but the small concrete statue on the bank still invited attention.

Roughly four feet high, the madonna, as I called her, a reproduction of a Frank Lloyd Wright–designed sculp-ture, was placed so that she looked down into the still wa-ter. She wasn't technically a madonna figure—she carried

no child—and her official title was garden sprite. But something in her crossed arms, gentle, down-turned face, and simple Greek-icon lines reminded me forcefully of the madonna statues I'd seen in Europe.

And one statue in particular. Another madonna figure, and also without a baby—I'd met this statue in the botanical gardens in Brussels. Something in her kind but melancholy face, which was painted black, had touched me deeply, as had the skinny dog and stunted tree by her side. In my mind I had named her the Madonna of Sorrow; recovering from a depression myself, I'd had a sudden intuitive revelation at that moment—the nature of sorrow and joy intertwined.

"Never one without the other," I said out loud now. "Two halves of a whole, the yin and the yang." Somehow the notion was extraordinarily freeing and had been even more wonderfully liberating at the time. At that moment of understanding in the garden in Brussels, I had known that my depression was over. And somehow the little statue that now stood by my pond had reminded me of that other statue and the never-forgotten, still powerful revelation of her message. Blue had seen me admiring the icon-like concrete figure in a catalogue, and had surprised me with it on my last birthday. So there she stood, a constant, gentle symbol of a basic truth and a moment of pure and perfect freedom.

I sighed again. Life was indeed good. I had a husband I adored and who seemed quite fond of me, a garden and animals I delighted in, and I was expecting my first child.

In some ways it seemed as though all my wishes had mysteriously been granted.

Movement up on the brushy hillside near the ridgeline caught my eye and I looked up. Something tawny brown, in the clearing near the old pine snag. A deer? No. Smaller. A bobcat. The distinctive high-in-the-rear-end cat shape with its stubby tail was suddenly clear.

This bobcat seemed to be playing, tossing something up in the air and catching it, just like a domestic kitten. I stared, entranced, as the creature leaped and twisted and batted an object with his paws. The object appeared to be a dead rodent. I wondered if this was the same young bobcat that Blue and I had seen this morning from the bedroom window.

As I watched the cat play, movement on the other side of the clearing grabbed my attention. Another tawny brown shape moving steadily into view—another bobcat. I stared in surprise. I couldn't recall ever seeing two of the wild cats together; they tended to be solitary creatures.

The second bobcat approached the first, who stopped his play and first sniffed noses, then rubbed his cheek affectionately against the newcomer's face. I could see that the second cat was both bigger and a darker color than the first one, and seemed to be accepting his greeting with composure. Of course. Mama.

At a guess, the first bobcat was indeed the one we had seen this morning, just in the process of separating from his family of origin, and Mama was still keeping in touch. I watched the two animals socialize for a minute, then

Mama moved off and Junior went back to his rodent, carrying it off into the brush, presumably to devour it. In a moment, both were out of sight.

I blinked, taking in what I had just seen. A mother and her child. Soon I would be a mama. Placing my hands gently on the mound of my belly, I wondered what it would be like. It was one thing to feel like a mama to my unborn child; I had a strong suspicion that mothering a real, live, squirming, wailing baby would be a good deal more challenging.

Would I be good at it? Would I like doing it? Would I have the right instincts for it, as the mama bobcat did? The questions made my thigh muscles tense; consciously I tried to loosen them. I thought of Mac, my trusting little guy, curled in his warm, safe world. Soon we would be together in a different way—mother and babe-in-arms.

I could feel him move, and placed my hand on the spot. "How are you doing, Mac?" I murmured out loud.

Then came the answer, gently flowing through my brain into words I could understand. "I'm fine, Mama."

I sighed. I trusted his voice, trusted my instincts that told me all was well at this moment. No doubt I would get help at other stages as well.

After a minute I put my shirt back on again and picked up my book. *The Wind in the Willows*, one of the favorite books of my childhood. I was rereading it, imagining how I would some day read it to Mac. Time to hear Ratty's voice again.

I read; the sun shone, the breeze flickered in the euca-

lyptus tree on the ridge. An hour later, Mole and Rat were face-to-face with Pan, and I heard the low rumble of a diesel engine, accompanied by the crunch of tires on gravel. The pickup truck with the distinctive white plastic cabinets on the back was unmistakable. My old truck. Lucy was here.

Chapter 6

LUCY WAS OUT OF THE TRUCK and assembling her gear on the tailgate by the time I made it down to the barn. I grabbed Danny's halter off a peg and waddled out to get him, calling a greeting to Lucy over my shoulder.

As always, Danny stuck his nose obligingly into the halter, and I led him out of the pen and up to Lucy. She stroked his neck and shoulder, in the automatic, relaxed way of a natural horseman, before pressing her stethoscope to his heart girth.

We were both quiet while she listened, moved the stethoscope, and listened again. Slowly, she worked her way around the horse's rib cage, then repeated the process on his right side. When she was done, she looked up and met my eyes.

"His breathing's real labored. I can hear some wheezing. I'd say he has heaves."

"That was my first thought, too," I said. "But it seems odd to have it come on this suddenly. As far as I know, this horse was fine and then, bang, he has trouble breathing?"

"When was the last time he was ridden?"

I shrugged. "Could be two or three weeks ago."

We looked at each other again. I knew what she was thinking.

"Okay, you're right," I admitted. "We're not doing much of anything with the horses right now. I quit riding when I got pregnant, Blue's been really busy at work, and in the wintertime we're rained out a lot, anyway. I guess he could have been developing this for a while, and I might not have noticed." I stroked Danny's dark red shoulder, feeling guilty. "They've got big enough pens that they can run around as much as they want."

Lucy raised her hands in the air. "I'm not criticizing you. These horses look great, and I think the pens are plenty big enough for them to exercise themselves."

I smiled. "I'm sorry I sounded so defensive. I did spend a lot more time with these guys before I got pregnant, and I imagine I'll have even less time for them after I have the baby."

"It's part of life. It looks to me like you're giving them a lot nicer living situation than most horses get."

I gazed out over my pens, each a quarter of an acre, randomly dotted with young live oaks, and fenced with metal corral panels—the safest fencing that money could buy. Each horse had a roomy pasture shed that he was free to walk in and out of at his own choosing. My four Quarter Horse geldings had a reasonably comfortable life, even if I wasn't riding them at the moment.

"At least they don't live in box stalls," I said. "Or in little tiny pens where they can barely turn around. But I wish I had more time and energy for them. It's not that I'm not

interested in them anymore." I met Lucy's eyes. "I'm just as fond of them as ever. But since I quit riding, it seems different. I'm sort of a barn mama. They're my babies and I take care of them, but I'm not *doing* anything with them. Not like before."

"Do you miss it?" Lucy asked sympathetically.

"I don't know." I shrugged, feeling confused. "I'm not really interested in competing anymore. But I did like going for trail rides. Somehow, right now, all my focus seems to be on this human baby I'm going to have. I just want to take care of him. I don't seem to be willing to do anything that has the slightest risk involved."

"Do you think they miss being ridden?" Lucy smiled companionably as she rubbed Danny's forehead.

"Well, Gunner, the oldest one, is twelve this year, that bay with the big blaze, and he's been struggling for a while with navicular in a back foot, so the rest isn't hurting him any. But Plumber, that's the little brown horse that's looking at us over the fence, he'd like to be ridden more, I know. Blue just doesn't have the time for it."

"What about the gray horse?"

"That's Mr. Twister. I acquired him last year when he tore up his meniscus joint. The owner wanted to put him down, but the guy was willing to give him to me instead. Twister's healing, but he isn't sound yet. We're a good match, 'cause he needs rest as much as I do."

"And this one?" Lucy stroked Danny's forehead and straightened his black forelock so that it lay neatly between his eyes.

"Up until today, I would have said this one needed riding and attention more than any of the others. He's the youngest one and he has the least miles on him. When Blue has time to ride, he usually rides Danny."

Lucy rubbed the underside of the horse's neck, and smiled as he stretched out in pleasure. "He seems like a real sweet horse."

I laughed. "He's the most pettable horse I've got. He'll stand here all day and hold perfectly still for you to pet him. He won't pester you or nip you or step on your feet, and he never moves away from you."

Lucy laughed. "He sounds like a real angel."

I shrugged and ran a hand down Danny's rump. "He's got his stuff, like they all do. In his case, he'll sometimes crowhop when you first get on him. He doesn't buck hard, but it's annoying."

"I'll bet."

"So, what do you say—we start him on some corticosteroids and a little bronchodilator?" I asked her.

"That's what I'd do."

"Me, too."

"Let me grab some for you." Lucy turned back to the truck to collect the medications.

I led Danny over to the patch of green grass in front of the barn and let him put his head down and munch. Fortunately, the two medicines Lucy was about to give me could be administered orally. Fortunately, too, Danny accepted the process of having things squirted onto his tongue with no resistance at all, obligingly opening

his mouth and swallowing wormer paste or anything else.

Lucy handed me drugs and syringes.

"Twice a day with the one and once with the other, right?" I reminded myself.

"Right."

"Even though it's only been a few months since I quit working, it all seems so far away," I said apologetically. "I feel like I've forgotten almost everything I ever knew. All I think about is mama stuff. I don't know whether it's pregnancy hormones or what. At this point I can't imagine how I'll manage to go back to being a vet."

"You will," Lucy said with confidence. "When you're ready."

"I hope you're right. Let's give this guy his first dose."

With Lucy's help, I squirted the clear fluid containing the dexamethasone and the thicker Ventipulmin Syrup onto the back of Danny's tongue and held his muzzle up while he swallowed them.

"That should make you feel better," I told him. "Would you like to come up to the house?" I added to Lucy.

"I'd better go," she said regretfully. "I've got five more calls to get through by the end of the day."

"Five? Whew, you're busy."

"Every day is crammed," Lucy admitted.

"How are you doing with it?"

"Oh, I guess I'm still in the honeymoon period. I don't mind. I'm really enjoying being the doctor after all those years of vet school."

"Yeah, I remember those days," I said a little wistfully.

"I know, I know, it wears off."

"Not entirely," I said. "The job is always interesting, or at least it was to me; I did get tired of the long hours."

"I'm sure that will happen to me, too. I'm just trying to enjoy the enthusiastic period while it lasts."

"Good luck to you. I'm envious," I said with a smile, not sure if it was true or not.

Lucy grinned and said good-bye. I put Danny back in his pen and plodded back to the porch, tired from the short walk up the hill.

Settling myself back in my chair, I rubbed my belly with both hands. "Your mama's out of shape, Mac," I said out loud.

For a second, I contemplated my present and future with a sort of amazed dismay. I was so used to thinking of myself as a competent veterinarian, a successful single woman, a reasonably fit, trim, and active person. In less than one short year I had metamorphosed into a sedate, sedentary, married, stay-at-home mom. Was this really what I wanted?

I stared at the weedy vegetable beds, remembering a not-so-distant time when I would immediately have jumped into action, grubbing out all that sow thistle and Bermuda grass. Now, though the thought might be there, the impulse simply wasn't. I merely sat and stared.

It seemed I had entered into a gestational period emotionally as well as physically. Gone were those busy, generative days when I obsessively planned and planted and tended. At the moment I was involved in watching.

A bird flew past the porch, catching the periphery of my vision with its swooping, bouncy flight, like a child skipping down the street. Blue jay, I thought, and then turned my head to see.

Sure enough, a blue jay. Interesting that I could recognize a bird by its pattern of flight, even as I could name the authors of the tweets and trills that came from the brush, despite the fact that I couldn't see them. This sitting and watching produced something—a kind of intimate, intuitive knowledge that couldn't be acquired any other way. What it was worth, I didn't know.

What I did know was that this meditative state felt both appropriate and foreign, alien as it was to the woman I had always been. I was a person of action, both by my nature and the demands of my job. I made decisions, chose a course, told others what they needed to do. Not anymore. Passive waiting and observing filled my days, and yet passive wasn't quite right. What I was doing was active in its own way, a subtlety I couldn't explain even to myself.

Ambivalent, that's what I was. I couldn't decide whether I found my current life enjoyable or onerous.

Picking up my book once more, I sighed. Was I losing the person I had been? If so, who would take her place? Some sort of tranquil mama that I couldn't currently envision?

No answers came to mind. I read some more and waited.

An hour later, Blue drove in, home from work a little

early. I greeted him with undue enthusiasm, grateful to have someone to talk to.

"I don't know," I told him. "Sometimes all this sitting around at home gets to me. Other times I like it."

"It's a big change," Blue said. "You could go out."

"I know. I'm only limited by my own notion that I need to rest and be quiet. And you know, paradoxically, it feels right. I just can't seem to get used to it."

Blue nodded. "How's Danny?" he asked.

I recounted the details of Lucy's visit, and Blue walked down to the barn to check on the horse and do the evening feeding chores.

When he came back, he shook his head. "He doesn't look too perky."

"I know. He ought to feel better in a day or two."

Just as Blue opened his mouth to make a comment, the phone rang. Shrugging, he stepped into the house and brought me the receiver, a habit of his that dated from the time he had first moved in, when he was officially "living" in his travel trailer parked in my yard.

"Hello," I said.

"Gail, something's happened."

Jenny's voice. I felt a fist contract in my gut, a visceral sensation of fear. "What?" I asked cautiously.

Jenny took an audible breath. "Charley's here," she said.

Chapter 7

"CHARLEY, YOUR EX?"

"Yeah."

"This is bad?"

A silence. Then, "It's difficult. In more than one way. It's not just that he's here."

I waited. I could hear Jenny's intake of breath, nothing else. Exasperated, I demanded, "Jenny, what is it then? Will you tell me what is wrong?"

"Can you come over here?"

"Now?"

Another silence. Then, "Yes, now."

I took a deep breath myself. "All right," I said, "if you need me." I hung up the phone and met Blue's eyes.

"Jenny?" he asked.

"That's right. She wants me to come over—now. Apparently Charley's there."

Blue looked both puzzled and mildly exasperated. "So you're going?"

"I guess I am." Reading his expression, I added, "I know it's annoying. But Blue, Jenny's the closest thing I have to

a sister and she seems so troubled right now. I feel like she really does need my support. She doesn't have anyone else."

"I see what you mean." Blue's nature, always calm and reflective, precluded any strenuous objections to my choice. "I'll cook some dinner," he said.

"I'll be back home as soon as I can," I promised.

And then it was back to my truck and out San Andreas Road to the old Monterey Bay Ranch.

On the way, I thought of Jenny. Jenny as a child, in the long, green, leafy summers I had spent at my aunt's house in Michigan. Jenny slim and tanned, her hair a wet red-gold mane, diving into the neighborhood lake, looking to my eyes like a mermaid.

Unlike Jenny, I was an indifferent swimmer, much more comfortable on land than water. Lying stretched on the raft, watching her exuberant dives, I felt envious and admiring. Jenny had always seemed so special—talented, competent, full of life. How had she become so distressed?

Her affair, the divorce, the move from Michigan? All these things were possible reasons, all were certainly big and upsetting events, yet I had the sense that there was something more.

I sighed, not really seeing the clump of Monterey pines as I turned in the ranch driveway. There was some kind of mysterious problem bothering Jenny, something that she wouldn't tell me. All these hints of nefarious dealings at the racetrack must allude to something. The question was, what?

Bumping down the road to Jenny's house on the cliff, I pondered what I knew, which wasn't much. Maybe Charley would provide a clue.

A thin line of sunset orange glowed on the horizon above the ocean as I stepped out of my truck and stared at Jenny's house. No lights were on; no cars were in the driveway. Only Jenny's big white dually pickup. Slowly, I walked to the door.

A knock elicited no response. Wrapping my denim shirt more closely around my body, I made my way around to the porch on the ocean side. As I neared the corner of the house I froze. Over the loud roar of the surf came what sounded like the strident scream of a woman. Shrill, piercing, it mingled with the cries of the seagulls and died away.

I blinked. Had I really heard it? Was it just an aberrant gull? Eerily, all was silent again. Only the ocean boomed.

My heart pounded. One foot in front of the other, I stepped cautiously toward the corner of the building and rounded it. My eyes scanned the long expanse of deck.

Two figures, one unquestionably Jenny, with her back to the windowed wall, facing...who?

A woman. A woman with long, grayish blond hair and loose, shapeless clothes. Not a young woman — a woman of about my own age. A woman in an odd pose, head thrust forward like a crow's. And then she screamed.

Mouth wide open, eyes glaring, a long, angry crescendo pouring from her mouth in the direction of my perfectly silent, statuelike cousin. I stared at this impossible

scene with a complete lack of comprehension. My feet seemed riveted to the boards of the deck, my mind stuck in a stutter-step.

I was fairly sure I did not know this woman. Nothing about her seemed familiar. I had no idea what a screaming woman would be doing on Jenny's porch. I had expected to greet a reasonably amicable ex-husband, not a demented street creature.

Demented. The woman was talking now, a long, jabbering stream, slurred enough that I couldn't entirely understand it, though I caught a peppering of words like "slut" and "bitch." As far as I could tell, it was a rambling monologue of invective, aimed at my apparently catatonic relative.

Jenny wasn't answering the woman; she hadn't even glanced at me; I wasn't sure she knew I was here. She watched the crazy lady pour out a tirade without making any observable response.

I had never, that I could remember, confronted a woman who was actually screaming with rage. Spittle flew from her mouth as she burst out with a furious and barely intelligible, "You dirty bitch! Did you think you were going to ruin my life and then just walk away?"

On these words she whirled toward me, her long hair snaking around her. Our eyes met; I tried to school my face into a calm, neutral mask. Automatically, I folded my arms protectively over my belly. It's okay, Mac, I soothed silently. It's okay.

I wasn't at all sure about this, though. The longer I

observed her, the more certain I became that the woman was truly psychotic, not merely drunk. Something in her unfocused gaze seemed deranged rather than drugged.

What in the hell was I supposed to do here?

Before I could get further than this, the woman started toward me.

My heart revved up, thudding frantically in my chest; my ears roared. Should I try to run? Stand my ground? Yell at her?

In another second she wheeled and paced back to face Jenny. Once again she opened her mouth and screeched, again I could see the spittle flying.

Before I could take another breath she was marching my way again, toward me, past me. I wasn't even sure she saw me. She rounded the corner of the house, muttering a monologue of angry curses and disappeared in the direction of the driveway.

I unstuck my feet and lumbered as fast as I could toward my cousin. "Jenny, are you all right? What in the world is going on? Who was that?"

Jenny barely seemed to take in my babbling; she hardly seemed to be aware of my presence.

"Jenny!" I virtually shouted, and reached out and shook her shoulder. "What's the matter?"

Another blink. Then, in an oddly calm, detached voice Jenny said, "That was Annie."

"Annie?" For a second I hadn't a clue, then I remembered. "Your lover's wife."

"Yes."

"Oh," I said. I tried to register what Jenny might be feeling about this and failed. Jenny's face was blank, apparently emotionless.

"Annie doesn't look sane," I said.

"Yes," Jenny agreed in the weirdly flat tone.

"Jenny!" I said, more sharply then I'd intended. "Will you please explain what is going on? You called me and said Charley was here and you wanted me, and I arrived to find this. I just don't get it." I shivered.

The sun had dropped below the horizon and the briefly glowing sunset was ebbing to a chalky, smoke gray dusk. The temperature was dropping precipitously, in the way of winter evenings, and the chilly wind blowing briskly off the ocean didn't help.

"Can we go inside, please," I said plaintively. "I'm cold."

Without a word, Jenny slid the glass door open and walked into the house. I followed her into the living room, which was only marginally warmer than the porch.

Wrapping my arms about my body, I said, "Can you tell me something, anything? Was Charley here?"

Jenny marched directly to the bar on the other side of the room, produced a short glass tumbler and a bottle of Maker's Mark bourbon and poured herself a shot, looked a question at me and then shook her head. "That's right, you don't drink," she muttered, and tossed the brown liquid down her throat.

I waited until she was done and had poured herself another shot before I said, "Jenny, please."

Jenny took a much more ladylike sip of her second drink and sighed. "Come on, Gail. Sit down. I'll explain. If any of this can be explained."

Seating myself on a couch that faced the windows, I once again made an effort to compose my face into a patient, calm mold. Jenny sat down in an armchair to my left, sipped her drink, and began to talk.

Chapter 8

"YES, CHARLEY WAS HERE. We got in a big argument and he left. That's when I called you."

"Wait a minute," I demanded. "What was the argument about? Why was Charley here? Did he just show up on your doorstep unannounced?" This was the trouble with talking to Jenny; like many Michigan natives I had met, she favored a laconic, even a telegraphic, conversational style, and I often found myself unable to deduce the necessary background information between the lines.

"That's right," Jenny agreed, "he just showed up."

This sounded evasive to me, but I shut my mouth and waited for more.

"He wanted to warn me that Annie had apparently told everyone she knew that she was coming to California to kill me. He thought she might actually have flown out here. No one's seen her for a while."

I took this in. "My God. Do you think Annie's your stalker?"

Jenny shrugged. "I don't know. It's possible, I guess."

"My God," I said again. "She just stepped off your

porch and is wandering around your property. Shouldn't we call the police?"

Jenny gave me a straight look. The whiskey seemed to be relaxing her. "Gail, I ruined that poor woman's life and pushed her off the deep end by screwing around with her husband. I haven't got the heart to throw her in jail."

"Well, at least lock your doors and call Juan and have him look for her. You don't want her burning your barns down or charging in here with a sharp knife," I insisted.

This seemed to get through. Obediently, Jenny got up and locked the doors and made the phone call. I stared at the opaque blackness beyond the uncurtained wall of glass in front of me and felt uncomfortable. Anyone— crazy Annie, or a host of other stalkers—could be out there on the porch staring in at us; we'd never know it.

Jenny returned to her chair and took another sip of her drink. I waited with what I thought was a reasonable amount of patience for more information to be forth-coming.

Jenny seemed quite content to sit in silence.

"So, what did you and Charley fight about?" I prompted.

Jenny thought about this. "He wants me to come back," she said finally. "He doesn't like me living out here on my own. He says he's worried about me."

"Because of Annie?"

"That, and just in general."

"And you fought, because?"

"Because I'm not going back," Jenny said simply. "I'm done with that life."

"Jenny," I said cautiously, "you don't seem all that happy here to me. At times you seem pretty unhappy. Are you sure this is where you want to be?"

Jenny met my worried gaze for a long moment. Looking into those blue-green eyes that I'd known so well and for so many years, I was genuinely startled by the blank, empty depths. Like well water, cold and deep and clear, Jenny's eyes were fathomless and somehow chilly. "It doesn't matter where I am," she said steadily. "I don't suppose I'm going to be happy. But I'm not going back to Charley. There's too much water gone under that bridge already."

Something in her tone gave me no doubt that she meant every word. "And Don?" I asked.

"I'm not interested in Don. I'm not very interested in anything, if you want to know the truth." Jenny finished her second drink in a long swallow and poured herself a third.

I sighed. I recognized this emotion, or rather, lack of emotion, from the time when I myself had gone through a depression. Jenny's almost robotlike demeanor was deeply familiar—and more than a little scary. "Is there anything I can do to help?" I said finally.

"Just your being here is helping a lot."

I softened. "I'm glad. But Jenny, you know I can't stay here. I've got a husband and a home of my own. And I'm seven months pregnant and tired and I need to go back and eat. Do you want to come over and have dinner with us? You'd be more than welcome."

Jenny met my eyes again, with that oddly compelling, empty gaze. "It's okay, Gail," she said, in a voice as remote as her eyes. "I really don't feel like going anywhere. But thanks for the offer."

I remembered this behavior, too. In the grips of depression, I'd virtually refused to leave my home, resisting the efforts of well-meaning friends to drag me out. I'd preferred to stay holed up—an injured animal in its den.

I stood up. "I'm worried about you," I said. "Why don't you come home with me?"

"Don't worry." Jenny stood up, too, and walked me to the back door. "I just need to stay here. This is my home now. I'm not going to leave it—or be driven out of it."

"You should eat," I protested, as I stepped out into the night. "Not just drink."

"I'll eat," Jenny agreed. "Go home to Blue." And she shut the door behind me.

Hunching my shoulders, I plodded through the winter blackness to my truck, looking over my shoulder and straining all my senses to spot movement or noise in the darkness around me.

Nothing. Nothing but the wind tossing the boughs of the pine trees and the steady roar and boom of the surf. In the distance, I heard a horse neigh. Closer, an owl hooted, a soft, comforting sound. I reached my truck and leveraged my bulky body into the driver's seat, heaving a sigh of relief as I locked the door behind me and started the engine.

Driving down the long, bumpy driveway, I peered through the windshield for a glimpse of a wandering

figure, but saw nothing out of the ordinary. Lights were on in Juan's house, but no one was about. No Crazy Annie anywhere to be seen.

Where had she gone? As I struck the main road, I looked both ways, but saw no pedestrians in the glow of my headlights. Annie seemed to have disappeared as enigmatically as she had appeared.

I didn't like it. In one short moment, facing those wild eyes, all Jenny's stalker paranoia had been transformed into something eminently more unsettling. I believed that Crazy Annie was capable of illogical, hate-driven action. It was quite possible Jenny really did have a stalker.

All the way home, I pondered my options. Even if Annie truly was a threat, I still wasn't sure what the police could do. Issue a restraining order, maybe.

And what could I do to help Jenny? I could hardly drag her over to my place, kicking and screaming. I couldn't force her to eat right or drink less. I felt Mac kick and shifted my attention to the bulge in my belly.

"Are you okay?" I said out loud. "Time for Mama to eat? I think so, too."

As my truck lunged and thumped up my own rutted gravel drive, I fixed my eyes on the bright windows of my little cabin, perched on the hill above me. Blue had turned the porch lights on and the house looked deeply welcoming, illuminated and glowing as a fairytale cottage, sparkling with life. Smoke curled upward from the chimney and I could see Blue's tall figure through the glass, his back to the room as he stood at the stove.

Parking my truck in the drive by the house, I gave a deep sigh of relief. I thanked God I wasn't Jenny, with her elegant home on the cliff, her perfectly appointed ranch, and her miserable life. I gave endless thanks for my humble cabin, my shabby garden, my ordinary livestock in their unpretentious corrals and sheds. And then I added extra thanks for Blue, my kind, considerate and easygoing spouse—not to mention, he was a good cook.

At the thought, I climbed out of the truck and trudged as fast as I could toward the house, aware of how hungry I was. Aware, too, that for what seemed the first time in my almost forty years of life, Cousin Jenny was someone to pity rather than envy.

That this was a change, I understood. I just didn't understand the immensity of it.

Chapter 9

THE NEXT MORNING ANOTHER storm blew in. In the changeable way of February our weather had shifted from clear, sunny, and seventy degrees to cold, wet, and windy overnight. Blue built a fire in the woodstove before he left for work; the house was warm and cozy. Trouble was, I didn't feel like staying in the house. Morosely, I stood staring out the windows at the garden.

Winter was back with a vengeance. Trees tossed and thrashed against a solidly gray sky, rain blew in horizontal sheets, vines and bushes flickered and shuddered. Drops spattered the windows and rattled on the tin roof. Water sheeted the porch, puddled in the yard, dripped from every twig. I gazed out and sighed.

I was tired of winter storms. I'd had my share of being housebound; I was ready for spring, and this year was in some ways worse than usual: I didn't have work to keep myself occupied. This year, pregnant and at home alone with my thoughts and the rain, I had a real case of cabin fever.

I would go see Jenny, I decided. Jenny clearly needed a

little support, and I was all she had. For once I wouldn't call her, I'd just drop by and see how she was doing.

Five minutes later I was bundled in a baggy sweatshirt that zipped over my belly—barely. Pulling the hood over my head, I waded through the bombarding rain to the truck and climbed inside.

Drops pounded the windshield; the wipers could barely work fast enough to keep the glass clean. The redwoods and oaks along my drive were somber dark shapes in a heavy gray gloom as I drove out the front gate.

Slowly I made the trek to Jenny's ranch, enjoying, even on such a blustery day, the greater light and openness over the ocean. Jenny's house huddled forlornly on its windswept cliff; an unfamiliar car was parked in her driveway. A rental car, I noted. I hurried a little as I clambered out of my truck, curious and worried at the same time.

Rain spattered down—not quite the deluge that had drenched me at home, though. Perhaps the storm was letting up. I made it to the back porch and raised my hand to bang it on the door. And then I stopped, midway through the action, fist inches from wood.

Voices. Loud voices. Jenny's and a man. Now the man was yelling, "Dammit, Jenny, I've told you and told you and told you. It's not safe; it's really not safe."

Then Jenny, sounding a good deal more forceful than I'd heard her lately. "And I've told you. You'll just have to trust me."

At this, there was silence. A silence that was somehow very unnerving. I knocked hastily on the door and turned

the handle in the same moment. The door opened. "Jenny!" I called, as I stepped in.

My rapidly scanning eyes found Jenny folded into an armchair, her hand over her face. In front of her stood a man, his stance belligerent, his jaw thrust forward.

I took this in. "Hi, Charley," I said as brightly as I could manage.

He was already turning, alerted to my presence. Despite the circumstances, an instant grin flashed across his features. "Well, hi, Gail," he said.

Charley Parker looked much as he had when I'd seen him last summer—short and stout, an energetic fireplug of a man. Charley carried a spare tire around his waist, his hair was thinning, and he had never been particularly handsome. But his blue eyes snapped with electricity and his body bristled with restlessly determined motion. Charley was a man of action.

He marched toward me now, hand outstretched in greeting, his argument with Jenny discarded for the moment as he discarded his newspaper into her lap, his whole being lit up with welcoming warmth.

"It's good to see you, Mama." Charley's arm reached across my back as he kissed me on the cheek. "You look wonderful. And how's Blue?"

"Just fine." I accepted the kiss and moved out from under the arm. "Charley, what is going on here? I heard you arguing with Jenny." My gaze shifted to my cousin, who still sat collapsed into the depths of the chair, her hand shielding her face. "Jenny, are you okay?" I demanded.

[89]

Jenny lifted the newspaper off her lap and waved it in my general direction. "Read this," she said.

I saw Charley's glance shift rapidly to Jenny; in reply she said brusquely, "She was here last night when Annie was; she knows about her."

Charley looked back at me. I was scanning what appeared to be the back page of the local paper.

"It's circled," Charley said briefly.

Sure enough, there it was. "Picked up as drunk on San Andreas Rd., Ann Chase, aged 47, resident of White Lake, Michigan."

"My God," I said. "Annie."

"That's right." Jenny's voice was a monotone. "She was picked up a mile down the road from my driveway headed toward town."

I was reading the paper. Annie had been arrested at approximately seven o'clock, not two hours after she had marched off Jenny's porch.

"Poor woman." Charley's voice was formally condoling. "I'm going down to the jail to bail her out."

Jenny said nothing. I had the impression there was a lot being left unsaid.

"Right," Charley said. "I'd better get to it. Good to see you, Gail. Take care of yourself," to Jenny, and then Charley was marching energetically out the door.

I sank down next to my cousin's chair. The storm had definitely abated; I could see a few blue holes opening up over the Monterey Bay. Jenny's wide windows gave a lighthouse keeper's view.

Jenny broke the silence. "Poor thing," she said at last. "It's all my fault."

"Because you had an affair with her husband?"

"That, and…" Jenny hesitated, "everything."

"What do you mean?" I asked her.

Jenny stared out her windows at the unsettled ocean, thick with choppy whitecaps. "I'm bad luck," she said at last.

I shook my head. "I don't think so. Jenny, you need to pull yourself out of this mood, if you can. You seem determined to be in trouble."

"I am in trouble," Jenny muttered. "Look at Annie. If that's not trouble, what is?"

"Jenny, do you think Annie's your stalker? Or what do you think? I'm trying to help you, but I'm completely confused and you're not telling me anything."

"I can't."

"Then I can't help you." I rose awkwardly to go, exasperation dominating compassion, but stopped when I saw Jenny's mutely miserable face.

"Do you really think someone is stalking you?" I asked in a gentler tone.

"It's possible," Jenny said softly. "It's definitely possible."

"Who would do that to you, if it's not Annie?"

"I don't know who exactly. Honestly, Gail, I don't."

"Well, what are you picturing? Some nefarious person from your racehorse past?"

At this I could feel Jenny spook like a startled horse — no perceptible motion really, only the slightest of cringes — but the reaction was there; no doubt in my mind.

"You're thinking of something, Jenny, I know you are. This would be a whole lot easier if you'd just tell me what it is."

"I can't, Gail. I really can't." Jenny hesitated, and I thought she might be about to say something more. But her lips folded themselves into a thin line as her body seemed to fold in on itself, curling deeper into the chair.

I stared at her in frustration, torn between sympathy for her obvious distress and annoyance at what struck me as completely unhelpful behavior. "Jenny, give me something to go on here, please. I don't know what to do."

At this my cousin looked right at me for the first time in our whole conversation. "All right, Gail, I'll give you one thing. And I really mean it. Stay out of this."

"Stay out of what?" I demanded.

Jenny met my eyes steadily. "My life," she said at last. "Or that part of my life. I'm sorry I ever said anything. Don't ask me any more questions, Gail."

She paused and for a brief moment we could both hear the rain pattering on the roof. Jenny took a deep breath. "Please."

Chapter 10

TWO HOURS LATER I WAS ON my way home. The storm had moved on; the sky was still gray, but nothing dripped from it at the moment, anyway. I had provided companionship and cooked toast and eggs for my cousin; I left her making the rounds of her barn, looking marginally more cheerful.

It was still a worry. Everything about Jenny was a worry right now. I had no idea what to make of her veiled warnings or what I should do about her all-too-obvious depression. Encourage her to see a shrink? I had a good idea what sort of reception that suggestion would get from Jenny.

As I pulled into my gate I glanced automatically at the horse corrals, a horseman's routine, cursory check, and my heart sank. Danny stood at the far end of his corral, head down, body hunched, his whole pose suggestive of misery. Blue had fed the horses and administered Danny's medication this morning; I hadn't really looked at the gelding since yesterday. And I already knew he was distinctly not better.

Another worry—just what I needed. Parking the truck, I climbed out into my sodden barnyard. Everything was wet, dank, and mucky, a soggy portrait in charcoal shadings. Squelching through the mud, some of which inched over the tops of my clogs, I walked out to Danny with a deep sense of foreboding.

Even as I approached the horse, my instincts shouted at me that something was very, very wrong. Danny's lower lip quivered and twitched, his eyes were dull and morose, focused on nothing. He didn't turn his head to greet me.

Stroking his neck, I ascertained that he wasn't sweaty, but his labored breathing seemed even more pronounced than yesterday. Danny was struggling. The steroids and bronchodilator definitely weren't helping.

"Don't worry," I murmured, "I'm working on it. We'll get help." Giving Danny's shoulder a pat, I headed back toward the truck and my cell phone, too worried to take the extra minutes that walking to the house would cost.

Fortunately Lucy was in; business was slow, due to the weather. "I'll be right there," she said, when I explained the situation. "We'll ultrasound him, see if we can find anything."

I ended the call with a sigh. I knew what she would be looking for. Fluid, which would indicate pneumonia; pus, which would be caused by an infection; or a tumor. The first two would be serious but potentially treatable, the last would be fatal.

Fatal. I took a deep breath. Faced the fear squarely. Danny could have something bad. It was possible that I

might lose him. Staring out over the muddy corral at his solitary, miserable silhouette, I felt my heart lurch.

Danny. The bay colt I had purchased just two short years ago as an unbroken three-year-old—the first horse I had ever started myself. I didn't have as much history with him as I did with Gunner and Plumber, my two older horses, but still, Danny was special. With his big, quiet eyes, his relaxed demeanor and easygoing personality— there was a certain depth in Danny that was different from other horses.

They were all different, I reminded myself, all special. I would hate to see any of them in trouble, struggling with a suffering that I couldn't alleviate. But was I doing enough for them?

All my energy, all my love, had gone out to Mac lately. The horses and dogs, my previous "babies," had definitely suffered as a result, if a lack of my attention could be called suffering. I had taken care of them in the basic ways, but my awareness was no longer trained on them as it used to be. And now, this.

Would I have spotted Danny's problem earlier, pre-pregnancy, in that time before I was obsessed with my un-born baby? Would I, perhaps, have been quicker to help my horse, treat his condition before it worsened? There was no way to know, but I wondered.

Watching my other three horses, who stood in a socia-ble knot where the fences of their pens met, I wondered if I was doing right by them. How much time or energy would I have for any of my animals once I had a baby?

Slowly, I waddled over to the hay barn and sat down on a bale. I had never really thought about this ramification of motherhood before I conceived. But it was distinctly possible that my animals were going to suffer from a lack of attention for a good many years.

Gray sky matched my mood. As I sat, not moving, a flock of quail emerged from the brush, one by one, feathers fluffed out against the weather, plump, gray pincushion birds. Bright-eyed, they pecked briskly at the remains of the hen scratch Blue had thrown to the chickens this morning, unworried by my silent presence a few feet away. I studied the white bars on their dust gray feathers, observed the slate blue males with nodding black plumes and rust-colored trim.

Life goes on, I reminded myself, watching the quail eat. You're not in charge, here, Gail. You can't control what happens, either with Danny or Mac. You can do your best to help, that's all. Beating yourself up isn't going to do any good.

It was true. Watching the quail was soothing; they seemed to impart a visceral sense of the wholeness of all life. I was a part of it all, not outside of it, not in control of it, just a part of it. Me and Mac and Danny and all of us, human, animal, and plant. There was nothing to do but my best guess in the moment.

"Like my mother used to say," I said out loud, scattering the quail, "worry is like a rocking chair. It keeps you busy but it doesn't get you anywhere."

Motion at the bottom of the driveway caught my eye.

Sure enough, Lucy was here. She must have dropped everything when she got my call.

Heaving myself up from the hay bale, I went to get a halter. Danny was caught and trudging obediently out the gate behind me by the time Lucy parked her truck and got out.

"Okay," she said, before her feet hit the ground. "Let's start over here. Vital signs first."

We took Danny's temperature, counted his respiration rate and his heartbeats, listened to his lungs and his gut. Nothing revealing. The horse's temp was normal, which argued against an infectious problem, his respiration was elevated, and his breathing labored. Heart rate and gum color were normal. He had plenty of gut sounds, perhaps more than usual. And overall, Lucy agreed, he looked worse.

"I brought our ultrasound machine," she said. "You and I both know it's underpowered for looking at a horse's lungs, but if I'm lucky, we'll get some reasonable images."

I did my best to hold Danny perfectly still as Lucy pressed the traducer to his side and peered at the screen. Fifteen minutes later, we were both stymied.

"There's nothing obvious there," Lucy said. "Or I can't see anything. Can you?"

I shook my head.

"You may need to haul this guy to the equine hospital at U. C. Davis if you want a diagnosis."

I nodded miserably. I had thought of this already. At the hospital they had much bigger and more powerful

X-ray and ultrasound equipment than we could afford in our small-town practice. But the hospital was three and a half long hours away.

"What do you think?" I said finally. "Start him on antibiotics, just in case?"

"Yeah," Lucy said. "I guess that's what I'd do."

"Yeah." I nodded. It was still possible that Danny had some kind of infectious problem going on in his lungs. "If he has a tumor…" I said slowly.

"I sure didn't see anything like that," Lucy answered, "but it's hard to be confident, with this machine. The left lung looked a little consolidated, but there was nothing obvious. Still," she hesitated, "my gut feeling isn't good. He might be checking out."

"I know." I stood there, next to my horse, one hand on his side, trying to process the raw information. As I did I became aware, once again, of what seemed like an abnormal number of exceptionally loud gut noises.

"Do you hear what I hear?" I asked Lucy. "Listen to his gut."

We both stood quietly next to Danny, who waited patiently, head down, as we listened to his intestines gurgle.

"He's not colicked," I said slowly. "Now what could cause this that would be coupled with labored breathing?"

As our eyes met suddenly, I knew the same thought had crossed both our minds.

"There's your differential diagnosis," Lucy said, the "aha" look vivid on her face.

"But it's so unusual," I said. "A diaphragmatic hernia is

really uncommon. And this horse hasn't done anything to cause it."

"You can't watch 'em twenty-four hours a day," Lucy rebutted. "Surely he could have fallen down in his pen without your knowing."

"He could have," I agreed, "but the odds of that causing a diaphragmatic hernia are one in a thousand."

Lucy shrugged. "I agree. Still, it's possible. And the only way we're gonna know is if you haul him to Davis and have them x-ray him."

I nodded heavily. "Let's start him on antibiotics for now. See if he responds. That should tell us something."

"True enough." Lucy collected syringes and bottle from the truck. In a moment she had found Danny's jugular vein and was injecting the clear liquid antibiotic into it. "There you go," she said with a pat on his neck as she withdrew the needle. "Hope that helps. Let me know, Gail," she added, glancing at her watch. "I've got an appointment back at the clinic in fifteen minutes."

Taking the syringes, needles, and bottle she was handing me, I said, "Thanks, Lucy. I'll be in touch."

After she left, I put Danny back in his pen, watching him closely as he walked slowly off, wishing I could intuit what was wrong with him. The sky had cleared to a washed blue, with rafts of puffy white clouds floating across it. Cheering, I supposed, but not so much to me.

With a final look at Danny, I labored up the hill and climbed the steps to my front porch. Settling myself in my

preferred corner, I stared out over the sparkling, rain-wet garden. What to do?

Hauling Danny to the hospital at Davis seemed an immense, daunting prospect, given my current state. And for what? To be told he had a tumor, or a diaphragmatic hernia? Both were completely untreatable. There would be nothing I could do for my horse.

Tears came welling up out of my eyes and ran down my cheeks almost before I knew I was crying. Blinking, I got to my feet. I didn't want to cry right now. I wanted to be detached, to think reasonably about alternatives; I wanted a clear mind. I wanted to think like a vet, not a distraught horse owner.

Grabbing my watering can, I began giving the cymbidium orchids that sat on the porch a drink. Like moths, their wings spread wide, the blooms glowed in dusky, smoky, spice colors—claret red, burnt orange, dusty rose. Here was a particular favorite, cream with a wine-purple throat, given to me by Blue's mother, who had gotten it from her own mother, who in turn had received it from a friend in England during the Second World War. The friend's greenhouse had been commandeered to grow vegetables for the army, and she had sent her beloved orchids to her California correspondent.

As I watered the cymbidiums, I thought as I often did, about each individual plant, how unique it was, with its own character, its own story. This little chartreuse-green one was given to me by my friend Kris Griffith, before she moved away, just when I first started to get interested in

cymbidiums. And this odd yellow-and-maroon one, Jenny had brought me this one on my birthday.

Abruptly I sat back down in my chair, tears spilling down my cheeks, the brief composure that watering the orchids had given me vanishing in another wave of grief. My cousin Jenny appeared to be sinking in some dark quagmire of her own making, and I couldn't seem to help.

Putting my arms around my stomach, I cradled the baby inside. "I'm so scared," I said out loud. "Something's wrong with Jenny and I can't figure it out. Something's wrong with Danny, and I can't figure that out, either. What if something's wrong with you, Mac? Something I can't help. I don't think I can bear it."

Tears dripped off my chin onto my belly. The world seemed so fragile, so uncertain, disaster lurking around every corner, unrelentingly scary. Staring down at the horse corrals, I could see Danny's lowered head and hunched posture. It was just so sad.

For a long moment I let myself feel it, the deep sadness over Danny and Jenny, the worry about Mac, the not knowing what to do, my own frustration. I was afraid all the time now: afraid to buy so much as a baby blanket or a pair of booties for Mac, afraid that I would somehow jinx him with my overconfidence. I still couldn't trust that he would, or at least might, be perfectly fine. All my fears seemed to gather in one turmoil of worry about my baby. What if, what if, what if?

I took a deep breath. For a minute or two, I just sat with my fear, feeling its unreasoning, panicky swirl. Then, reso-

lutely, I got back on my feet and finished watering the cymbidiums.

"We'll be okay," I said softly to Mac. "I'm going to try and trust in that. Whatever happens. Today I'm going to buy you some baby clothes. And tomorrow I'll go try and have another talk with Jenny. I'll ask Blue to haul Danny to Davis and we'll see if we can find out what's wrong with him, if there's something we can do to help him. I'm going to keep on doing my best to play my part, which is all I can do. That and trust."

Chapter 11

WEDNESDAY MORNING DAWNED bright. I stared at the baby clothes lying on my dresser as Blue pulled on his jeans next to the bed.

"Thank you for doing this," I said.

"It's okay, Stormy. It needs doing, and it would be hard on you right now."

"It's hard on you, too, I know. You're so busy at work."

"Work is just work." Blue shrugged. "I can take a day off to take care of us."

"Take care of Danny, you mean."

"Danny's part of us. Part of our family. Taking care of him is taking care of us."

I smiled. "Well, hauling Danny to Davis is taking care of me. Because if you weren't here to do it, I'd have to."

"I know." Blue smiled back. "You wouldn't be able to rest, not knowing what was wrong with him."

"It's not just that. The veterinarian in me wants to get a diagnosis," I acknowledged. "But mostly I just want to do right by him. I don't know how to help him or even if I *can* help him. But it would sure make me feel bad if it turns

out that I could have helped him and I didn't do it—just out of being unwilling to try. So I guess we need to try. Do our best to find out what's wrong with him so we can help, if possible."

"I agree," Blue said. "Which is why I'm hauling him across the Valley."

"I hope you don't run into any tule fog."

"Bound to, this time of year."

"You ought to know."

Blue had been raised in California's San Joaquin Valley; he knew its weather and moods.

"With luck it will be a high fog," he said now. "That won't be a problem."

"Let's hope you have luck. Driving in bad fog is scary."

Blue smiled. "Everything's scary right now, isn't it?"

I sighed. "You're right. That's how I feel."

"Try not to worry. We're doing what we can do. Nothing terrible is happening at this moment. And we can't know what's ahead. Worrying won't help anything."

"I know," I agreed miserably. "I'm not usually such an anxious person. Maybe it's pregnancy hormones. Or maybe it's because I'm not doing anything active right now. I'm just resting and waiting. My gestational period." I tried to smile at this, but was aware that it wasn't an unqualified success.

"Well, I, for one, am glad you're willing to take it easy and gestate," said Blue, as he headed out toward the kitchen and coffee.

I sighed. Yes, it made sense. It made sense even to me.

But I was so used to being active. This was all such a big change.

Once again, my gaze drifted to the clothes and blanket lying on my dresser, the first things I'd actually bought for Mac. A soft little blue cotton overall with cowboys printed on it, with a matching jacket—quite appropriate, I'd thought. And a woven cotton baby blanket in blue and cream. Nothing out of the ordinary. But momentous to me. A statement that I actually believed in the reality of Mac, a baby that would soon lie in my arms.

Perhaps, just perhaps, nothing terrible would happen. I wouldn't miscarry, Mac wouldn't die in utero, he wouldn't be born with some terrible defect. Perhaps he would be a healthy, normal baby, cheerfully kicking his legs in the little outfit I'd bought him.

Perhaps. I sighed. It was still hard for me to believe. As Blue said, everything felt scary right now.

Unrelentingly, my mind went straight to my other objects of worry. Danny and Jenny. I was almost afraid to learn what was wrong with Danny. Some of the alternatives were just too—I rolled my eyes, here we go again—scary. And Jenny, what the hell was I going to do about Jenny?

That's not, strictly speaking, up to you, my mind rebutted. Oh sure, I snapped back. What am I supposed to do, wait around until she's so terminally depressed she commits suicide? I have to try and help her if I can.

Climbing heavily out of bed, I pulled on some sweatpants and a sweatshirt and walked into the other room to

have breakfast with Blue. Ten minutes later we were down in the barnyard loading Danny in the horse trailer. Keeping my jaw clenched in an effort not to cry, I gave the horse's neck a final pat as Blue tied him in the front stall of the trailer.

"Don't worry." Blue shepherded me out the door firmly and latched it behind me. "Try to remember that."

"I'll try," I said, doing my best to sound calm and detached.

I waited until Blue's taillights were out of sight before I let the tears spill.

Damn. I just wasn't used to being this weepy. I wasn't used to anything about pregnancy.

Slowly I trudged back up the hill and let the dogs out of their pen for a run. I fed the barn cats and the chickens, checked to make sure all water troughs were full and that my three remaining horses were eating happily. All being well, I heaved my bulk back into the cab of the truck. Time to check on Jenny.

Pastures so incandescently green they made me squint flowed on both sides of my truck as I drove into the old Monterey Bay Ranch. Spotting Jenny's pickup by the barn, I pulled in next to it and parked.

No Jenny in the big barn. I walked across the yard and stuck my head into the stallion barn next door.

Jenny's red-gold head was immediately visible, halfway down the aisle, holding the lead rope of a gray stallion who appeared to be in the process of mounting a mare.

Standing in the doorway, I watched as the gray horse rose up on his hind legs, draping his forelegs over the

shoulders of a chestnut mare whose head was being steadied by Jenny's foreman. Jenny held the stallion's lead rope confidently, giving him plenty of slack; at a guess, he was an experienced stud who knew his job and had a good attitude.

Sure enough. After the initial thrusts, the gray horse stayed poised over the mare for a long moment, then dropped quickly and adroitly to the ground, neatly sidestepping any possible blows that might be aimed at him by the mare's hind feet. For her part, the mare appeared completely docile, merely swishing her tail as the horse dismounted, allowing her handler to lead her calmly away.

I watched while Jenny put the gray stud horse back in a box stall, then stepped forward, calling her name.

Jenny smiled as she spotted me, not quite her old smile, but a smile nonetheless. "Hi, Gail."

"Breeding today?"

"Yep. Rocky this morning and Trouble this afternoon."

"Trouble?"

"In more ways than one." Jenny's grin was rueful as she indicated a dark stallion in a box stall two doors down.

"I take it the gray horse is Rocky?"

"That's right. He's a real gentleman. Minds his manners, easy to handle, lot of experience. Trouble is a whole 'nother deal."

Together we walked the aisle to stand outside the stall of a dark chestnut stallion with a white blotch on his forehead. The horse paced restlessly up and down, neighing from time to time, excited by the activity he had just seen.

"This time next year," Jenny said firmly, "I'm going to

have a breeding shed. I've picked out the spot and I'm ready to start construction. It is just not working out to breed these stallions here in the barn aisle, but I really don't have anywhere else yet."

"So, what's the story on this one?" I was staring at the agitated Trouble as I spoke.

"Storm Trouble is his name," Jenny said, her eyes on the horse. "Out of a Storm Cat mare. Five years old this spring, won a bunch of stakes races as a three- and four-year-old. This is his first breeding season and I've got quite a few mares here for him. And is he ever a nuisance."

"He's a bad one to handle?"

"Oh yeah. I let Juan do the breeding with him. I won't even go in the stall to feed him or blanket him. He almost got Juan just last week, and Juan's the most experienced stallion manager I've ever had."

"What happened?"

"Trouble grabbed for Juan's neck as Juan reached out to unbuckle the blanket. He connected, too; he's fast as a snake. The only thing that saved Juan was that he was wearing a heavy jacket and the horse mostly got a mouthful of padding."

"I know someone who was killed in just that way," I said, thinking of Mary Ellen Whiting, who had adored her Morgan stallion and insisted on managing and breeding him herself. Despite his rank behavior she'd always sworn he wouldn't hurt her; her assistant had watched helplessly when the stud had broken her neck, grabbing her and shaking her like a rag doll.

"Stallions can be seriously lethal," I said slowly.

"Don't I know it," Jenny agreed. "And though Trouble's the worst, he's not the only problem. That bay horse farther down is Gator; he's a little quieter and more experienced, but you definitely have to watch him."

I noted that each stallion had an empty box stall between himself and the next stallion. Curiously, I peered into the one next to Trouble. Completely empty but, I noticed, with a small door, maybe four feet high by two feet wide, leading to the stalls on each side.

"Escape door for humans," said Jenny, following my glance. "In case someone gets trapped in a stall with a bad stallion. They have little latches that work from both sides."

"The empty stalls in between I understand, and also the bars over the stall doors—I've seen them before. But escape hatches…" I smiled admiringly. "That's really ingenious."

Jenny smiled back. "Got to think of everything."

"Speaking of barns with everything, do you have a bathroom here?"

"Of course. Next to my office. Right as you come in."

Retracing my steps down the barn aisle, I located Jenny's office, and stepped inside. A remodeled box stall—the wooden-floored space crowded with two desks and the usual clutter of papers, pens, calendars, file folders, and the ubiquitous computer monitor and keyboard. Another door led to a very utilitarian and not terribly tidy bathroom, fitted into the next box stall down. I noted the little

escape door in the far wall and realized that the gray stud horse was housed next door; I could hear the rustle and thud of his footfalls as he paced his stall.

When I was done, I walked back into the office, glancing at Jenny's desk curiously. An open engagement calendar seemed to have breeding dates for the stallions; next to it a closed, leather-covered book proclaimed itself a diary. A stack of books alongside appeared to be veterinary manuals of one sort or another, topped with a layer of horse-oriented magazines.

Ambling out into the barn aisle, I looked around for my cousin. There she was, peering into the stall of the bay stallion she'd called Gator. I walked in that direction.

"So, what's the story on him?" I asked Jenny.

She shook her head. "He's eight this year and knows his work, unlike Trouble. This is his third season as a stud horse. He's just mean. And he's real dominant. Dictator of the universe, that's old Gator. Always trying to prove he's the boss, not some pesky little human. I let Juan handle him, too."

"Has he grabbed at anyone?"

"Not here. They retired him from racing because an exercise boy pissed him off."

"You're kidding."

Jenny grinned, a real grin, with some humor in it. "Old Gator just reached around and plucked that guy off his back and tried to stomp him into the ground."

"Really?"

"Yep. Dropped that kid on the ground in front of him

and by all accounts made every effort to paw the guy to death with his front hooves."

"Wow." I stared at the bay horse, who stared back for a second, then returned to pacing and neighing, as Trouble was doing at the other end of the aisle.

"It is just not working to breed the mares in here," Jenny said ruefully. "It gets the horses too excited. I have to be really careful when we go in the stalls to catch them. Trouble tried to run Juan over the other day and push out the door. And if he ever gets loose, watch out."

"Would he go ballistic?"

"He'd be real hard to catch, for one thing," Jenny said.

I nodded slowly. "I drove out on a call to a ranch where they were raising registered paints. They had a couple of young stallions who had gotten loose. Just as I drove in I saw the owner trying to catch them; one of them, the darker paint, who was normally really easy to handle, reared up and struck at her with a front hoof."

"They'd probably been running around nickering to the mares and getting themselves all worked up," Jenny said matter-of-factly. "If they were left loose like that for long, no doubt they'd start tearing each other up."

"Would they hurt each other seriously, do you think?"

"Depends on the individual." Jenny shrugged. "Gator and Trouble would definitely do some damage to each other. Trouble would probably give up before Gator killed him; he's younger and I would bet not as genuinely tough. God forbid." Jenny shuddered. "They're both worth five hundred thousand at a bare minimum."

"I've had roosters fight to the death at my place," I said reflectively. "Some are just feistier than others. No one is making them do it; they have plenty of room to get away from each other, and yet I've seen them die because they won't quit fighting."

"Men." Jenny grinned again. "All that testosterone, you know."

"So true," I agreed. "So how are you this morning?"

"I'm okay," Jenny said in a tone that was neither particularly cheerful nor particularly depressed. "Just doing my morning rounds. Want to come with me?"

"Sure."

Slowing her pace to mine, Jenny led me out of the stallion barn and toward the big barn with the covered arena. Once again we paced down the immaculately raked and sprinkled barn aisle, peering into each stall we passed. Jenny studied the clipboards by the doors, scanned the inmates, and occasionally made a note on the horse's chart. All very routine.

I looked at the glossy, healthy Thoroughbreds with mild interest, my mind going back to my own horse, who was even now logging weary miles across the no-doubt foggy San Joaquin Valley with Blue at the wheel. Crossing my fingers, I wished fervently that Danny would be all right, that he wouldn't have to suffer. I was trying to imagine the most positive possible outcome when Jenny said, "Oh my God." Something in her tone had the stillness of death.

"What?" My head jerked around; my eyes searched for

my cousin. One minute she had been calmly checking on her charges; what could possibly have precipitated the genuine despair in her voice?

Jenny was staring into a stall, looking at a bay horse, her face horrified. "Oh shit," she whispered.

Something in her tone caused a strong, instinctive shudder to run down my spine—pure dread.

"What's wrong?" I demanded, hurrying toward her.

Jenny barely seemed aware of my presence. "Bingo. He's moonblind."

Chapter 12

I STARED AT BINGO'S LEFT EYE, half-shut and with a blue cast, then back at Jenny. "You think he's come down with moonblindness?" I asked her, sounding as blank as I felt.

"Yes." The horror in Jenny's voice was plain; it just wasn't explicable to me.

"Why do you assume it's moonblindness?" I asked her. "Maybe he just scratched the eye, or banged it on something." What I wondered, but didn't say, was why moonblindness was such an apparently terrifying prospect. Granted she had one blind horse due to that cause, but surely Bingo was just a retired pet, and moonblindness wasn't always, or even usually, permanent.

Jenny was off on another track. "My God," she said again. "What am I going to do?"

"First we need to check and see if the horse has really come down with moonblindness," I said, a bit impatiently.

Jenny peered briefly into the next stall, occupied by the old white horse. "Just like you, Sunday," she said quietly.

"Jenny, we don't know that."

"I do." Once again she looked at Bingo. "I'm so sorry," she whispered.

I stared at her in consternation. "Jenny, why are you assuming this is moonblindness, or that this horse will necessarily end up permanently blind? I don't understand."

"No, Gail, you don't understand. I know."

"Can you tell me?" I asked gently.

Jenny's eyes never left Bingo. "Perhaps I'll have to," she said at last. "Though it won't do any good. This is a sign."

"A sign of what?" I asked, impatience creeping back into my voice.

Jenny shrugged. Then, more practically, "What should we do for Bingo?"

"Stain his eye and see if he's injured it. If not, I'd start him on Banamine to reduce the edema and dexasporin—that's a triple antibiotic eye ointment combined with a steroid. Most of these," I gestured at Bingo's eye, "clear up pretty readily with prompt treatment. Even if they are caused by moonblindness."

"Can you do it?"

"No," I said firmly. "He'll probably need tranquilizers and I don't have them. Or any of the other stuff." Most horses did not care to have their eyes messed with and I was definitely not up for wrestling with a fourteen-hundred-pound Thoroughbred. Not in my delicate condition. "I'll call Lucy for you, if you want. She's good."

"I've had her out," Jenny agreed. "She's fine. A little easier to get along with than your boss." Jenny handed me

her cell phone. "Maybe if you call it'll get her out here quicker."

After some to-and-froing with the office, I was able to get Lucy on her cell; she assured me she'd be out at Jenny's place within two hours.

"And now," I took my cousin's elbow, "let's go to the house, where we can talk. It won't help your horse to stand here and worry about him. I know. I'm in a similar predicament."

I told Jenny about Danny as we walked out to her truck; driving the brief distance to her home she seemed to relax a little, as though hearing my troubles put her own in perspective.

When we were ensconced in chairs on her deck, looking over the ocean, a dazzling aquamarine in the pure morning air, I said firmly, "Jenny, you need to tell me what's frightening you. What is it about Bingo coming up with a bad eye that's so upsetting?"

Jenny's gaze remained fixed on the shifting surf and whirling gulls; for many long seconds she neither moved nor spoke. I waited, knowing she was weighing her options; I wondered if she would retreat, as she had so far, into an unmovable position of silence.

In the end, she sighed, a small, resigned sigh. "You will not repeat what I say to anyone?" she said formally, so quietly that I barely caught her words over the boom of the not-so-distant breakers.

"I won't," I promised, mentally crossing my fingers that this would not prove too difficult a commitment to keep.

"It's hard to know where to begin," Jenny murmured.

"You remember, I told you about Don, and how Charley and I partnered with him on some horses?"

"Yeah," I agreed, wondering where this was leading.

"One of those horses, years ago now, maybe five years, was in a good position to win an important stakes race. We were all a little in the hole at that point, and winning the race would save everybody's ass. The purse money alone would get Don out of a very tight place, let alone what we could collect by betting. The horse himself was ready to win; there was only one other horse in the field who had a good chance of beating him. And this other horse was the favorite.

"I'm still not sure who thought of it, Charley or Don, but they had a friend who was our vet; he worked at the racetrack and knew everyone. Ted, the vet, well, there had been rumors about him in the past. Talk that he'd been known to help fix a race.

"Anyway, no one asked my opinion; they didn't even tell me what they were doing—I found out later—but either Charley or Don approached Ted to help them eliminate the other horse. At the time I had no idea it wasn't a complete coincidence, but one day before the race," Jenny turned her head to look straight at me, "the favorite came down with moonblindness."

For a second I took in what she had said; I could feel my eyes widen, even as my mouth opened into the amazed "O" of a startled cartoon character. "Are you trying to tell me that you think this vet was able to *cause* the horse to come down with moonblindness?"

"I know he did," Jenny said simply.

[117]

"But, Jenny, we're not even sure what triggers moon-blindness; how could he possibly cause the disease?"

"I assume you've heard of leptospirosis?"

"Sure," I agreed. "Lepto" was a bacterial disease that could be a problem in cattle, horses, dogs—even people.

"And you've heard of the vaccine?"

"Yes," I said. And suddenly a light clicked on. "Lepto vaccines have been known to cause moonblindness," I said slowly. "I've read about that. If you get a hot batch. It's a modified live vaccine and sometimes, in some batches, the virulence is too high. A few studies have shown a cor-relation between that and incidences of moonblindness in horses. But how would a person know they had a lepto vaccine like that?"

"Ted apparently had a particular batch of vaccines that the lab had recalled for that reason," Jenny said. "He didn't actually know how effective they would be at caus-ing moonblindness; they turned out to be very effective."

"So, your horse won the race and everyone was happy," I said.

"More or less. The favorite had to be scratched but he eventually recovered completely; I never knew it had been anything but a fortunate chance. But, of course, it didn't stop there."

"They got greedy," I guessed.

"Someone did," Jenny said somberly. "I never really knew which one. The first time was more or less a fluke, but after that they ran a few tests to determine if they could count on that vaccine to cause moonblindness, and

it turned out that they could—about ninety-five percent of the time." Once again she looked straight into my eyes, her own gaze opaque and apparently emotionless. "Sunday," she said.

"Sunday? Oh my God. You mean Sunday was one of their trials?"

"Him and several other pony horses or retirees they thought were worthless. After they found out they could cause moonblindness virtually every time, they got a little more elaborate with their fixes."

"Geez." I was taking in the implications. "And no one would ever be suspicious, because no one would imagine moonblindness to be a thing that someone could cause."

"Exactly," Jenny said. "They started to look for races all over the place, looking for the right situation. They'd wait for one that was shaping up to be a two-horse race where our horse was one of the two. They'd inject the other horse, and usually it worked. Between the purses and the bets, they made a lot of money."

"Was the other horse always scratched?" I asked. "Wasn't that a little obvious?"

"Not so much," Jenny said, "because moonblindness is such a weird disease. Sometimes the people would think the horse had just injured his eye and it wouldn't look too bad, a little swollen, maybe, and they'd run him anyway. But, of course, he wouldn't usually run very well. Those eyes are real painful. Sometimes the problem never got diagnosed as moonblindness—sometimes it did. Sometimes the horse went permanently blind in one eye, or even

both, sometimes he made a complete recovery. Like you said yourself, it's an odd disease and vets really don't understand it very well. I found all this out later," she added glumly.

"My God," I said. "How did you find out?"

"Charley just couldn't keep his mouth shut." Jenny's voice was level. "I knew he was up to something crooked, nobody could be that lucky. Eventually he told me what was going on. Charley's a talker, you know. It was hard for him to keep a secret from me."

"And Don?"

"I confronted him with it. It wasn't pretty."

"What did you do?"

"Told them they had to stop," Jenny said briefly. "But they didn't. And in the end I left. Left them both."

We were quiet for a while as I tried to process this new information. "And all the money they made?"

Jenny shrugged. "I got my fair share of it. As you see. Now you know how I could afford all this." Once again she gave me that direct look. "In exchange for my silence."

I took that in. "So just who are you so afraid of?" I asked her. "Charley? Don? Annie? Did Annie know?"

"I don't know," Jenny said quietly.

"Don't know what?"

"I don't know if Annie knew about it; I'm not sure what I'm afraid of. By the time I left, there were lots of other people involved. People to place bets, people who could help hide the money, people who got cut in on the deal for one reason or another. None of them were good

people. All of them have a big interest in my not blowing the whistle."

"So this is still going on?" I demanded.

"I'm sure it is. Why would they quit? When I left they were running horses at six different racetracks. It wouldn't do to have a big outbreak of moonblindness in Detroit. But an isolated case here or there, a carefully chosen race where they could clean up; it was making them all richer and richer. Why would they quit?" she repeated.

"But you don't know for sure."

"No, I don't know. I moved out here to start a new life and get away from the whole thing. But it's just not working out."

"You think one of them is stalking you?"

"I'm sure of it. Someone wants me really scared so I'll keep quiet."

"My God," I said. "Would Charley do that to you?"

Jenny's eyes were deep and cold as the Monterey Bay. "I don't know," she said. "I just don't know."

Chapter 13

THE SHRILL BUZZ OF A CELL phone broke the moment; Juan announced to Jenny that Lucy had arrived. In the ensuing shuffle out to the barn, the topic of Jenny's "problem" was dropped, at least overtly. My mind was still busy with what she had told me; I felt sure that hers was, too.

The next half hour was full of the usual brouhaha of doctoring horses. Lucy was greeted, Bingo was led out, his eye examined, stained, and scanned with a penlight—no easy feat with a head-shy, sixteen-hand Thoroughbred. Between Juan, Jenny, and a few cc's of tranquilizer, Bingo was restrained to the degree that Lucy, with difficulty, got a fair look at the clouded eye. When she pronounced that she saw no injury and suspected moonblindness, Jenny's gaze dropped to the raked dirt of the barn aisle.

Jesus, I thought. Whether or not Bingo's problem was caused by sabotage, Jenny was going to be certain that it was the result of a deliberate attack. What this would do to her fragile emotional balance, I couldn't imagine.

More shocks were in order. Lucy doled out medica-

tions and instructions and departed; before her truck had vanished down the driveway, a white sedan pulled up in front of the barn. Charley Parker got out of it.

Jenny's cringe at the sight of her ex-husband was obvious; I had a hard time hiding my own shudder. The thought that this man had engineered the blinding of a number of horses caused a physical sense of revulsion; I could feel myself involuntarily stepping backward as he approached.

True to form, Charley's smile was apparently genial; his blue eyes virtually twinkled with ready warmth. I wasn't sure if it was imagination or intuition that prompted me to see a certain steely coldness under the friendly surface.

"Gail. Jenny. How's it going?"

"Fine," Jenny responded, and shot me a warning look.

Taking this to mean: don't mention Bingo, I kept my mouth shut and merely smiled and nodded.

"What are you here for?" Jenny said quietly.

At her words, Charley toned his genial persona down several degrees. "Have you seen Annie?" he asked, in equally clipped syllables.

"No." Jenny looked down.

"I bailed her out of jail and she disappeared," Charley said. "Didn't meet me where she said she would; no one's heard of her at the address she gave. Don flew out yesterday to try to talk her into going into some sort of program—she's off the deep end for sure—and now I can't find her."

"Don's out here?" Jenny sounded truly shocked.

"Arrived yesterday," Charley said tersely.

"Oh my God."

"I'm surprised he hasn't been out here to see you."

"I haven't got any wish to see Don, Charley. Not that it matters."

For a second the two of them locked eyes; I could sense that some of the issues that had ended their marriage were very much present in both their minds.

Then Charley's gaze shifted and he smiled, a not entirely pleasant smile. "I guess you're shit out of luck then," he said.

I looked where he was looking and saw another little sedan pull somewhat hesitantly into the barnyard. At that point the driver seemed to spot us; he parked the car and got out. I noted that the license plate frames proclaimed the car a rental and then raised my eyes to the face of the approaching man.

He was markedly handsome by anybody's standards, including mine. Tall, square-shouldered, and slim, with black hair and olive skin and the sort of face that looked as if it could have been etched on some old coin. A prominent, straight nose, square jaw, high brow, his dark good looks well set off by a black turtleneck and jeans. His sideburns showed a touch of gray, but despite the fact that he was surely at least forty, Don Chase, for I presumed it was he, looked remarkably well preserved.

One glance at Jenny's dismayed face confirmed my guess. She looked as if she'd rather have been anywhere but here, face-to-face with her ex-husband and ex-lover.

Not to mention, the coauthors of the nefarious scheme to fix races by blinding racehorses, I reminded myself.

"Hey, Don," Charley said casually and without apparent rancor.

"Charley." Don acknowledged his partner briefly but his eyes were on my cousin. "Jenny," he said quietly, "how are you?"

Jenny tipped her chin back. "Never better," she said crisply, with a flash of the old Jenny-spirit. "So what are you doing out here, Don? Chasing after your wife?"

Don Chase seemed to visibly deflate—the thrown-back shoulders slumped forward, the handsome mouth just curving in a slight smile drooped. "That's right," he said.

Since none of the players involved in this little drama seemed inclined to introduce me, I took a step forward. "I'm Gail McCarthy," I said, holding out my hand. "Jenny's cousin."

"I'm sorry, Gail," Jenny said hastily. "This is Don Chase."

I shook hands with Jenny's former lover and could definitely see what she'd seen in him. The contrast between his lean, aristocratic demeanor and Charley's short, stout energy was almost ludicrous. However, he wouldn't have been my choice; something in Don Chase's dark eyes seemed to smirk that he was pretty and he knew it. I recalled Jenny saying that he had a big ego.

"Nice to meet you." Don Chase mouthed the words automatically and barely met my eyes. I had the sense that he was not so much dismissing my rotund self as unworthy

of his attention, merely deeply preoccupied with his own problems.

"Annie hasn't been out here?" he asked Jenny.

"Not that I know of. Not since she was thrown in jail," Jenny said.

"Charley said she was here before, bothering you?" Don's eyes were fixed on Jenny's face.

Jenny shrugged, a gesture both acknowledging and dismissive. I was struck by her reluctance to meet her former lover's eyes; Jenny's face was turned to the side, her own gaze locked firmly on her barn. Every inch of her rigid stance proclaimed her discomfort in the presence of these two men.

Don turned to Charley. "We've got to find her."

"Damn right we do. I paid her bail."

I wondered whether the urgency apparent in both men's voices reflected concern over Annie's welfare or worry that she was somehow a threat to them. Even as I stood quietly watching them talk in the spring sunshine, I could hear Jenny's strange story in my head; the image of a man walking down a darkened barn aisle to inject a racehorse with leptospirosis vaccine was uncannily present. Which of these two was the leader? Which of them had chosen to put that first horse out of commission? And was one of them trying to frighten Jenny into silence?

On the face of things, it looked unlikely. Neither Don Chase nor Charley Parker caught my fancy in the role of a stalker. Annie? Or was Jenny herself the problem?

I had to admit that my tense and overwrought cousin

seemed quite likely in the character of a woman imagining improbable threats. At the same time, I believed her story about moonblindness. It was just too unlikely to be something she'd invented.

I shifted my gaze from one man to the other. They were engaged in their own communication and seemed indifferent to my curious stare. As Jenny's largely pregnant cousin whom they thought ignorant of their problems, I was more or less invisible.

Don Chase stood with his shoulders thrown back and his chin up; as he spoke, he turned his head slightly from one side to the other, as if he were posing, showing off his profile. It was undoubtedly a handsome profile, but I was struck by the oddness of what appeared to be a virtually automatic behavior. As if the man imagined himself to be always on stage, the star of some invisible show. He didn't seem to be posturing for Jenny or Charley, much less for me, just acting—as if acting were normal for him. There was a nervous, uneasy edge to him that I found disconcerting.

Charley, for his part, seemed not to notice this almost mechanistic behavior of Don's; of course, if it was as habitual as it appeared, Charley was used to it by now. As always, Charley Parker moved and spoke with an intense energy that belied his thick, heavy body. As he and Don discussed possible ways of finding Annie, it was clear that Charley was the leader in the partnership, Don the follower.

I turned my gaze back to Jenny. She wasn't watching either of the men, just staring in an unfocused way in the

direction of her barn. Tuning everything and everyone out, I reckoned. What did it mean? Distaste at being in the presence of her ex-husband and ex-lover? Fear that they were currently traumatizing her by various nefarious acts—poisoning her dog, blinding her horse? I couldn't tell by looking at Jenny. She just appeared to be checking out of the present situation, for whatever reason.

As for me, the more I stood there, the more uneasy I felt. The dynamic of our little group seemed charged with some form of menace, something I couldn't put an intuitive finger on. Just that it was there, a sense of a conspiracy tightening, a threat poised. Just like—I winced at the unfortunate metaphor and almost looked up—sitting under the sword of Damocles.

At this moment, my cell phone rang, causing me to jump, and everyone present to pat their pockets gingerly, assuring themselves that it wasn't their cell.

It was Blue. Even before I heard his voice a ball of dread ballooned in my gut, rising to my throat in an "oh no" I could feel.

"So, what's wrong with him?" I asked in as calm a voice as I could manage.

Blue hesitated; I could feel the kindness in his hesitation and it scared me.

"Just tell me," I demanded.

"He's got a diaphragmatic hernia," Blue said.

"They're sure?"

"They're sure. They x-rayed him. Apparently they could see his guts all mixed up with his lungs. That's why

it's hard for him to breathe. His lungs don't have enough room."

"So, what's the prognosis?" I hoped I sounded cool and collected, despite the fact that I felt like I was in a falling elevator.

"They don't really know. These things are so uncommon. He could live awhile as a pasture ornament. It can't be fixed; he can't exert himself."

I nodded. I more or less knew all this.

"I'm on my way home," Blue said. "I'll tell you everything when I get there."

"How is Danny right now?" I asked.

"He's fine. A little dopey, from the drugs they gave him to get him to hold still, but fine. How are you?"

"Fine," I said, in my best laconic, Michigan-type style. "Drive careful. See you soon."

Jenny, Charley, and Don were all staring at me as I ended the call. Despite the odd circumstances, I felt an urge to confide my disaster to people who were, if nothing else, fellow horsemen.

"My horse has a diaphragmatic hernia," I said.

They all looked blank. That was the thing. I had been visited by a disaster so rare that experienced horsemen had never even heard of it. Lucky me.

"What's that?" Charley asked cautiously.

"For whatever reason, a fall, some sort of trauma, the wall between the intestines and the lungs has ruptured. The guts spill out into the abdominal cavity, causing various problems."

"My God," Charley spoke with his usual force. "That's one thing that's never happened in my barn. Thank God."

"It's rare," I said briefly.

It was a measure of how tightly wound this little group felt that no one, not even Jenny, expressed any sympathy for my plight. One and all remained focused on their own agenda: Jenny looking distant; the two men resuming their talk of a search for Annie.

As for me, I'd had enough.

"I'm going home," I said quietly to Jenny.

Instantly she snapped to attention. "Now?"

The urgency in her voice silenced the men. Jenny would never plead, but there was a pleading tone underneath the one word.

"I can stay a little longer," I relented. My eyes scanned the group, eventually coming to rest on Charley's face. "Do you think that Annie is a threat to Jenny?"

Charley met my gaze; those bright blue irises fairly crackled. For a second I had the notion he was adding things up, calculating how I might fit into an equation of his own creation. When he eventually answered, it was in a relatively quiet, deliberate tone, for Charley, anyway. "I don't know," he said. "I guess it's possible."

I thought back to the contorted features of the woman I had last seen screaming into Jenny's face and thought it was more than possible. Unfortunately, it seemed at this moment that it was equally possible that Charley himself was a threat to Jenny. Not to mention Don. For that matter I wasn't sure how much Jenny's own word was worth.

She seemed so lost in her personal crisis that I could imagine her fully capable of perceiving stalkers in the chance events of everyday life.

Turning my eyes to Jenny, I saw that her face was once again averted from the group, her eyes remote, her stance rigid. Despite the fact that she clearly wanted me to stay by her side, she obviously had no intention of interacting with anyone present.

I sighed. I didn't see what I could usefully do here. Charley and Don had gone back to formulating a plan to track down Annie; since I didn't trust them, I could hardly confide in them. And Jenny just wasn't speaking.

With cursory farewell noises, the two men were moving toward cars, having apparently established where each would search.

I touched Jenny's arm. With a level "Bye" to her two exes, she turned to face me. Once again I felt my stomach drop. The empty depth in those quiet blue eyes was unnerving. This was most emphatically *not* the Jenny I had always known.

"Are you okay?" I asked.

"I'm fine."

"You don't exactly look fine."

"I'll be better once they're gone." She waved a hand at the departing vehicles.

"Jenny," I began tentatively. "I'm not sure what to do here. Do you feel like you're in danger?"

Jenny's even response was a mirror image of Charley's. "I don't know."

"Should we call the cops? I know someone in the local sheriff's department."

"No," Jenny said, with more firmness than she'd shown so far. "I don't want that."

"All right," I said. "I sure don't know what to do. And much as I want to be a help to you, you know I can't stay here all day everyday." I shifted from foot to foot as I spoke; I was already weary from being on my feet for over an hour.

Jenny seemed to notice the motion. "Go home, Gail," she said abruptly. "I really appreciate you staying until they left. But go home now. Get a little rest before Blue brings your horse back."

"Okay," I said, hoping the relief I felt wasn't too palpable. "I'll get going. You'll be okay?"

"Sure."

Once again I turned my back on Cousin Jenny with a definite sense of foreboding. This was all getting too repetitive. Everytime I left her ranch my stomach tied itself in knots with worry.

As I drove home, the worry shifted from Jenny to Danny. My God. My five-year-old horse was crippled for life. How in the hell was I supposed to deal with that?

Ready tears dripped down my face; I cursed them and my own too-emotional state. Even as I pulled in my driveway and dragged myself through the process of making lunch, I found I was wiping moisture off my cheeks. Damn.

Done with my peanut butter–covered bagel, I looked around the empty house. My usually cozy cabin appeared

as forlorn as I felt, dirty dishes on the counter, wilted flowers in the vases, drifts of dog hair on the floor. Sighing, I shoved my feet into motion and began the inevitable process.

An hour later the kitchen was clean, the floor swept, a load of laundry chugged in the washer. I'd dumped all the vases on my little flower "altar" and was busy arranging the fresh flowers I'd snipped. The altar was merely the windowsill over my kitchen sink; several years ago I'd had the notion to arrange a row of vases there and keep them filled with fresh flowers from my garden. Over time the idea of an altar had emerged; I felt the flowers were a constant reminder of the flow of Nature in the world around me.

The only rule was that I wasn't allowed to buy flowers, or bring them from somewhere else. My altar was to celebrate this special place, my home, and the passage of the seasons through my own garden. In February, of course, the choices were a good deal slimmer than in June, but I always managed.

Today a spray of cream-colored cymbidium orchids ornamented the tall blue glass bottle at one end of the sill; the neighboring green bottle held a curving wand of the salmon geranium that grew in a pot on the back porch. A cluster of yellow and orange jonquils crowded a turquoise glass jar and filled the kitchen with that fruity scent; the simple sea green bud vase held a single out-of-season apricot rose from my Lady Hillingdon bush. A tiny midnight blue ceramic jar bore an equally tiny early iris, and the last vase—an earth-colored pottery sake flask—was filled with

eager twining blue-green nasturtium tendrils, present only because we'd had no frosts so far this winter.

As I stood back to admire my shelf of flowers, I became aware that somewhere in the cleaning and arranging, I'd reached a new level of acceptance about Danny. Some part of me had acknowledged that I could not change the fact that he had the hernia; the only thing I could do was give him a good home for the rest of his life, however long or short that was.

It was still sad, but some of the struggle was gone; I felt a release. Rubbing my belly, I spoke aloud to Mac. "I'll do my best to take care of Danny, whatever happens, just like I'll always do my best to take care of you."

The words gave me a little peace, which vanished as soon as I thought of Jenny, who seemed to be struggling like a mermaid caught in a net. Trapped in an ever more bizarrely complicated snare, which didn't seem to offer any escape.

I gave a moment's thought to calling my friend Detective Jeri Ward even against Jenny's wishes, but gave it up. The whole situation sounded impossibly nebulous, when I imagined trying to describe it. What help could the cops provide, even if they wanted to? They certainly weren't going to supply a twenty-four-hour guard for Jenny.

I sighed again. Unlike Danny and Mac, I felt totally confused about Jenny. Was there anything I could do to help her? Or would she have to help herself? If the latter were true, was Jenny even willing to try to help herself?

At the thought, a picture arose in my mind of Jenny's

eyes, as they had looked these last few days. Remote, empty, and yes, I had to admit it, quietly despairing. What could it lead to?

Once again tears welled up; I scrubbed at my eyes hastily and stared firmly at the flowers. I didn't want to cry anymore. I was tired of crying. As I prepared to wait out the hours until Blue and Danny arrived, I resolved to defeat these hormones that were making me so weepy. "No more crying," I promised myself. I wasn't, however, betting any money on whether I'd be able to keep this vow.

Chapter 14

I GOT THE CALL AT MIDNIGHT.

Jenny's voice on the phone was matter-of-fact as always, if a little breathless, but her words were alarming. "Gail, can you come over? I'm having a disaster—maybe you can help."

Barely awake, I fumbled for the right words, worry and exasperation almost equally mixed in my mind. "A disaster?"

"The most valuable mare on the place is foaling. It's a nightmare. Lucy doesn't know what to do. Jim's out of town."

"My God." The shift from nebulous stalkers to foaling nightmares had me off balance. Before I could reflect on the wisdom of this course, I said, "I'll be right there."

The minute I hung up the phone, I wondered. What could I, in my enormously bulky, quintessentially fragile state possibly do to help? What on earth was this expedition going to achieve other than robbing me of some much-needed sleep? Nothing for it now; I'd agreed.

Reluctant to wake my sleeping husband, I left him a note on the bedside table and shuffled out, without disturbing either Blue or the canines, all sacked out blissfully on the bed.

Lucky me, I was plodding out to my pickup under a fortunately nearly full moon in a cloudless black sky. Silver-white light illuminated the yard in a ghostly parallel of high noon, shadows sharp and dark behind each gleaming leaf. I paused only briefly to admire the alchemy of night, the thought of an emergency C-section on a million-dollar mare pushing my reluctant feet toward the truck.

Disasters seemed to be escalating all around me. Only a few hours ago, I'd given Danny one last pat before I went to bed, the wet streaks on my face bearing silent testimony to my broken no-tears vow. Gingerly I patted my belly as I settled myself in the driver's seat. "Are you okay, Mac?" I whispered out loud.

As if on cue came the reassuring movement under my hand. In my mind the answer was clear. "I'm fine, Mama. Don't worry."

What the mental process was, I didn't understand, but for the moment, I trusted. Trusted in Mac's voice, in the rightness of the communication, in the truth that things really were fine with my baby.

Things were not, however, fine with Jenny. Seeing Lucy's truck in the barnyard and lights on in the big barn, I parked my own pickup and waddled inside, only to be greeted by a scene of full-blown carnage.

Jenny, Lucy, and the remains of the mare were all brilliantly lit in the central arena; blood was everywhere. Jenny and Lucy were covered in it; red rivulets still oozed from the mare's open abdomen. Lucy held a stethoscope to the ominously still form of a blood-smeared foal. Jenny sat cross-legged by what I instantly knew to be the carcass of the million-dollar horse.

There is a certain stillness, a flatness if you will, to a dead animal. I'd seen enough of them in my career to be sure in the first glance.

Clearly a C-section had been attempted, equally clearly it had not been successful. Lucy looked up and met my eyes.

"I'm not getting a pulse anymore," she said sadly. "And he never did take a breath."

At her words I felt a jolt like a punch in the solar plexus. I was all too suddenly aware that my usual veterinary detachment was gone. I was no longer a veterinarian looking at a medical dilemma; I was a mama looking at a dead mama and baby.

This could be me, were the words in my head. This could be me and Mac.

Trying to shake myself free of the vise I could feel tightening on my heart, I asked, "What happened?"

For a long moment neither woman spoke. Finally Jenny said quietly, "I'm not sure. The mare started into labor about dinnertime; everything seemed normal, but I called Lucy just in case. She is, was, the most valuable horse on the place.

"Lucy's been here the whole time. About an hour ago we both had a sense something wasn't going right. The mare was struggling and nothing was happening and then, intestines and stuff started coming out the birth canal."

Lucy shook her head. "It's a one-in-a-thousand thing. The foal's hooves must have perforated the wall of the uterus."

"We didn't know what to do. That's when I called you," Jenny added.

"I've never had one like this," Lucy said simply. "I knew the mare wouldn't make it, so I tranquilized her and tried the C-section; I couldn't euthanize her until we got the foal out, if we wanted to give him a chance.

"I had a pulse to begin with," Lucy went on, "but it was weak, and he never took a breath. He's gone now. And I euthanized the mare. She had no chance of surviving."

"My God." I had no other words. The wet, dark body of the newborn foal lay still and pathetic in the clean sand of the exercise arena. The two blood-covered women and the equally still body of the mare with its gaping abdomen seemed to be weeping silently around it.

"I am so sorry," I said to both Jenny and Lucy. "I'm not sure I could have been any help, even if I had been here earlier. I've never had one of these, either. I've heard of it, but it's really rare."

"The people that own her are going to be devastated," Jenny said grimly. "They've put so much into her and they're really fond of her. She was a nice mare." I could hear the catch in her voice as she spoke. "I'd better go call

them. They'd want to know." She got up with her head hanging and her shoulders slumped forward.

Out of the corner of my eye, I saw Juan step into the arena. "Should I call the tallow truck?" His voice was low but audible.

"Better wait," Jenny muttered. "I need to know what the owners want."

They walked out together, absorbed in the pragmatic details of ranch management. I looked over at Lucy.

"This is hard, I know."

Lucy shook her head dejectedly. "It is hard. You try to be professional, but…" She shrugged. "What a bummer."

I was staring at the foal's body. *He's just a newborn baby, a little baby, just like Mac, just like my baby. This could happen to us.* The ominous chant played over and over in my head.

You've seen plenty of blood, I told myself firmly. *You've dealt with lots of sad endings. This is no different.*

But it was. Now I was a mama, or a mama-to-be, anyway. Everything was different. I felt Mac kick, a solid poke, and put my hand on the spot.

God protect my baby, protect me. Have mercy on these innocents, this other mama and her baby.

I didn't really know what the words meant to me, or what mercy might mean to a dead horse. I only knew the words were there, in my mind, soon to be accompanied, I realized with a blink, by yet more tears.

"I'm sorry, Lucy," I said awkwardly, putting a hand on her shoulder and turning away so that she wouldn't see me crying. "I'd better find Jenny."

My cousin was in her office staring down in a distracted way at the diary on her desk.

"God, Jenny," I said quietly. "This must be really tough on top of everything else."

Jenny didn't say a word. She didn't appear to be crying, just gazing downward in an unfocused way.

"Is there anything I can do to help?" I asked her.

"No, nothing really." Jenny's voice was calm, even detached, almost eerily so.

"Are you sure?"

"I'm sure. Go on home, Gail. Get some sleep. And thanks for coming." Jenny looked at me directly, with what was almost, but not quite a smile. "Don't worry," she said quietly. "I'll be fine."

Chapter 15

SOMEHOW I DIDN'T BELIEVE HER. Whether it was her tone or the look in her eyes or just the stark reality of the situation, I wasn't sure. Whatever the reason, I didn't get much sleep, visions of the dead mare and foal and Jenny's empty eyes whirling through my head the rest of the night.

By nine o'clock the next morning, I was once again on my way out to the old Monterey Bay Ranch. The winter sunlight, so bright and pure, was an uncomfortable contrast to my troubled mind. Bracing myself against the sharp brilliance, I tried to think calming thoughts.

Down the ranch road with its lining of white-fenced pastures, past the big barn, a glance telling me that Jenny's pickup wasn't there, and around the band of dark pines until I was bumping up to Jenny's solitary house on the cliff. Even its intrinsic drama failed me this morning. I barely saw the glamorous silhouette outlined against the wide ocean-horizon before I was banging on the door.

Jenny's truck was parked in the driveway, but the hollow wooden reverberations of my knocking produced no

response. Only a windy silence filled with the distant boom of surf and occasional seagull screeches.

Maybe Jenny was drinking coffee on the porch. I made my way around the house, thinking as I did so that I wouldn't be visiting out here much when Mac was a toddler. I couldn't imagine trying to herd a two-year-old away from that sheer, unfenced drop.

No Jenny on the porch. I tried to still the rapid pounding of my heart. She must be here somewhere. Her truck was here. Forcing away an image of too much booze and pills and an unconscious form on the bedroom floor, I stared out at the distant horizon, then back to the house.

"Jenny," I called tentatively. Then louder. "Jenny!" No answer. I walked to the sliding glass door and pushed it open. "Jenny!" I called again, and the sound seemed to bounce off the walls.

Only silence replied. The living room was unlit, chilly, and smelled faintly of the cold ocean outside. "Jenny!" I shouted loudly. Nothing. No sound of running water from the bathroom. Not a whisper or a rustle. The house felt utterly empty, quiet as a tomb.

Forcing my unwilling feet, I stepped through the unnatural silence of the hall until I reached the half-closed bedroom door. "Jenny," I called softly, aware that there was fear in my voice. Getting no reply, I pushed the door open.

For a second my eyes roved the room, looking for a human shape. I could hear my breath hiss out in relief as I realized there was no one here. Jenny's bedroom was as empty as the rest of the house.

Maybe, I thought hopefully, she'd gone for a walk on the beach. She'd mentioned to me once that she sometimes did this in the morning. Giving a cursory glance into the empty bathroom, I headed back outside.

The deck was as deserted as ever. I gazed over the visible stretch of pristine sand. Not a soul in sight as far as I could see. Without really knowing why I did it, I stepped to the edge of the porch and looked down. Nothing but empty beach. Except...and my heart revved up into high gear.

Directly below me, something like clothes. Like an apricot-colored sweatshirt and blue jeans. Hadn't Jenny been wearing a sweatshirt of that color last night? I stared, disbelieving, not wanting to believe. Surely that was red hair — my God. That was Jenny.

I took one more long look at the terribly still form and waddled as fast as I could in the direction of the trail to the beach. I didn't think of calling for help, I hardly formed a thought. All I was doing was getting to Jenny as fast as I could.

Down the trail between the brushy ravine shoulders, stumbling as the beach rose up to meet me. Seagulls swerved in the brilliant sky, the house on the cliff hovered over me as I stepped out into the wide stretch of white sand. There, right below the deck, lay the blue-jean–clad form.

It was Jenny. I knew it as I trudged toward her, sinking and slipping in the sand. I knew it even as I denied it, willed it not to be true. Standing over her, dropping to my

knees, seeing the oddly twisted neck, the glazed eyes, knowing but not wanting to believe the reality.

Jenny was dead. Her cheek was chilly; she'd been dead some hours. I looked up at the looming house above me. No question but that Jenny had fallen from that deck. And before I could stop them, the thoughts bubbled up. Fallen? Jumped? Pushed?

Each scenario presented itself in an instant. The stumbling drunk, the depressed suicide, a victim of that threat she had believed was hovering over her?

"Oh, Jenny," I said, reaching for her cold hand. "Why did this have to happen?"

Sitting there for a few long minutes, I tried to connect with my cousin one more time, but even with my eyes fixed on her still, pale face I couldn't feel her spirit. Jenny seemed to be utterly gone; the quiet, empty body in front of me was simply not her. She wasn't here.

Where she was, I hadn't a clue. And it was clear that her body wasn't giving any hints. I knew that it would be time to go soon, time to face all the questions and logistics, but for the moment, I felt rooted to the spot. I just wanted to be with Jenny.

Her hand was limp and cold, her cheek, when I touched it again, felt waxy. It struck me that her expression was oddly peaceful for one who had died of a long drop. As though if she had not willingly jumped, she had at least not resisted the falling. She did not look afraid. More like accepting.

"Oh, Jenny," I said again. Whether it was shock or the

inherent drama of the moment, the tears that had been leaking from my eyes all week were absent. I just couldn't take it all in. Couldn't believe that Jenny was really gone.

Eventually I got to my feet. Amazingly the beach was still there, complete with glittering surf and swirling seagulls. And absolutely empty. Jenny's private beach, I thought sadly.

After one long, last look at my cousin's still form, I made my heavy, plodding way across the deep sand to the steep ravine trail. I was gasping for air by the time I emerged in Jenny's driveway. After a moment's thought, I walked to my pickup, found my cell phone, and dialed 911.

What followed was predictable. The operator's calm, detached voice assuring me that help was on the way, my search for Juan culminating in a short exchange with the shocked foreman, the arrival of sheriff's deputies and the long trek back down to the body, and finally, the inevitable consultation with a detective from the Santa Cruz County Sheriff's Department.

I knew two detectives in said department, and Detective Jeri Ward was a friend. But the man who questioned me as we stood in Jenny's living room was someone I'd never met.

Fair-skinned with grayish eyes and his probably blond hair cropped so short it was virtually invisible, Peter James, or so he introduced himself, looked like some sort of neo-Nazi to me. Though I was vaguely aware that this sort of voluntary baldness was currently in fashion, I still didn't find it the least bit appealing.

Nor was I impressed with Peter James. He seemed very full of himself, a trait I'd observed before in various cops, and he asked me questions pertaining to Jenny and her end in a curt tone that suggested he'd already drawn his own conclusions.

After ascertaining that she did drink and had been depressed, he appeared comfortably sure of himself; I had no trouble reading his thoughts. Jumped or fell. After a good many drinks, probably.

Though this wasn't so far from what I suspected myself, I hesitated when he asked me in a perfunctory way if I knew of anyone who would have a reason to wish her ill. Shit, was my first thought. What in hell was I supposed to say here?

Jenny's stalker scenario, Crazy Annie, Charley and Don, the whole racehorse scam involving moonblindness induced with a lepto vaccine? What should I say or not say? Did I really want to bring any of this up? Jenny was dead; nothing would bring her back.

Aware that the detective was staring at me I said lamely, "I'm racking my brain. I really can't think of anyone."

That this wasn't true I was all too aware. Telling myself I just needed a little time to think it all over before I opened that can of worms, I answered the detective's question about my own whereabouts and noticed a minute pricking of his ears as he discovered that I had been out here late last night and that I, along with her vet and foreman, had been one of the last people to see Jenny alive.

Juan had confirmed that my cousin had not come

down to the barn this morning. This wasn't uncommon; he hadn't worried, supposing her to be holed up on the phone with the owners of the dead mare. She sometimes didn't make it down to the barnyard until shortly before noon, he reported, so he hadn't thought anything of it.

Now, seeing the brief interest in the detective's eyes, I suddenly realized that I, as Jenny's cousin, could conceivably be a suspect. Ludicrous as it seemed in my heavily pregnant, all-too-fond-of-Jenny state, it made a certain amount of sense. Even more so when I heard the detective's next question.

"Do you know who is her closest living relative?"

Oh my God, was what I was thinking. What if I inherit her estate? And then, oh Jenny, I don't want your money, I just want you back.

For the first time since I had looked down from the deck and seen my cousin's body lying like a crumpled heap of old clothes, I felt the tears start to rise.

I blinked. "I am, I think. I'm sorry," I added. "I'm just now taking it in."

The detective watched me quietly. After a moment he said, "We'll check into a few things and be in touch. You'll be at this address and phone?" And he repeated back to me the information I had already given him.

I agreed that I would, and he promised to let me know the results of the crime scene investigation. At this, he took his leave, after escorting me to my truck.

Sitting, or rather collapsing, into the front seat of the pickup, I let the tears I had choked back roll down my

cheeks. My cousin was irretrievably gone; there was nothing left but this process of deciding what had ended her life.

And what was my part to be? The tears slowed as I contemplated for long moments the practical results of bringing up all the problems Jenny had confided to me. Did I even want to go there? One thing was for sure: It wouldn't bring her back. And it could bring a lot more trouble.

Did I owe it to Jenny? What would she have wanted?

I couldn't, I simply couldn't, decide. In the end, I came to a simple conclusion, one that often came to me. I needed to talk to Blue.

Chapter 16

BLUE WAS EMPHATIC. "Tell them everything you know."

"But…" I began. For some reason, being advised to be forthright was increasing my reluctance. Perhaps it was just my contrary nature; suddenly I was sure that I didn't want to tell the cops anything.

"What good will it do?" I demanded. "Jenny's dead. It won't bring her back. All it will do is stir up a lot of trouble that I don't particularly want to deal with."

Blue sat down next to me on the couch and put his arm around my shoulders. "I'm worried about you, Stormy," he said firmly. "If your cousin's death wasn't an accident, if someone really was stalking her and maybe even killed her, that person is going to see you as a potential threat. They're going to wonder if Jenny told her secret to you. As soon as you tell everything you know to the police, you're off the hook; there'd be no point in trying to silence you."

I hadn't thought of this. "I'm afraid I'm the number-one suspect at the moment," I said slowly. "If that detective is even considering the scenario that Jenny was murdered."

"You?" Blue sounded incredulous.

"Think about it. I was one of three people who were out at her place late last night and the other two have no reason to kill her. I, on the other hand, may be her heir."

"Are you?"

"I honestly have no idea. I hope not," I said candidly.

"It might amount to a lot of money," Blue said.

"I don't need Jenny's money. And I sure don't want to be investigated as the prime suspect if it turns out she was murdered."

"Do you think she was murdered?" Blue asked.

I shook my head. "I've thought of almost nothing else ever since I found her. She told me her past might come back to haunt her, she described that moonblindness scam, I saw her ex-lover's wife threaten her, Charley and Don are both out here…that's a lot to have going on. On the other hand, I've been worried these last few days that she might have been depressed enough to be suicidal; there's no question she might have knocked back quite a bit of booze after last night's disaster and either jumped or just fell accidentally from that deck."

And suddenly I choked up. "I'm sorry," I gasped out, trying to hold back the tears, "I go along just fine and then suddenly it hits me. Jenny's dead. I knew she was in trouble and I couldn't help her. Whether she jumped or was pushed or just fell because she was drinking too much, she's gone. I just couldn't help her." And I broke down and sobbed with my head against Blue's chest.

Blue stroked my hair and let me cry. It took a long time. My composure would return for a minute and then

a new wave of grief would break over me. I held Blue; I wrapped my arms around my belly and sobbed until I was out of breath. Finally, finally, the tears abated.

"I think I'm okay," I said shakily.

"Just take it easy, Stormy. No wonder you're upset. Finding Jenny like that. After being worried about her."

"Up until now I was doing okay. Or maybe I was just in denial." I sniffed back more tears. "I still can't really believe it. And I just don't have any intuition about it. Jenny's face looked so peaceful and accepting; I keep wondering if she jumped."

"Maybe the police can determine something."

"Maybe," I agreed dubiously. "They'll probably do an autopsy." I winced at the thought. "And maybe they'll look for any sign of a struggle on the deck. But what else can they tell?"

"If she was dead-drunk, I suppose. Or if someone injected her with something. If she died of the fall, maybe."

"You're suggesting someone might have killed her and then pushed her body off the deck?"

"It occurred to me. If I wanted to make sure someone was dead, I wouldn't trust that the fall would kill them."

At this I shuddered. The thought of Charley or Don purposefully killing Jenny to silence her and then throwing her body off the deck was just too horrible. I tried to picture Annie doing it and could only imagine a hasty shove.

"But who else could it be?" I said out loud. "If it wasn't Charley or Don or Annie? If it *was* someone."

"Someone else involved in their racehorse fixing scam, maybe," Blue answered. "Didn't Jenny tell you there were a lot of people making money on that deal?"

"Yeah, she did," I agreed. "I guess that kind of leaves the field wide open."

"Which is all the more reason for you to tell that detective everything you know. Everything Jenny told you, anyway. And then make it public knowledge that you did so."

"Charley and his buddy Don will hate me, that's for sure."

"Do you care?"

"No. Not really. As long as they don't come after me."

"They've got a hell of a lot more reason to come after you if they don't think you've told anyone."

I sighed, and stared out my big south-facing windows at the overgrown vegetable garden. A clear winter evening was just ebbing to a chilly dusk. I could see the silvery rim of the rising moon behind the eucalyptus tree on the eastern ridge.

Between the morning's ordeal, Blue's hasty return from work at my call, and some long hours of his comfort, day was over. I didn't feel the slightest bit hungry, but a flutter from Mac reminded me that I should eat for his sake.

As if reading my mind, Blue stood up. "I'll put some steaks on the barbecue and cook some rice," he said.

"Thanks." I stood up, too. "I'll go feed the animals."

Plodding on down to the barn, I distributed alfalfa hay, hen scratch, and cat and dog crumbles. Danny still looked a little morose, but perhaps less so, as if he were adjusting

to the status quo. He was eating his hay with a reasonable amount of enthusiasm, anyway. And me? I was getting adjusted to Danny's situation, but I certainly hadn't adjusted to Jenny's death; I'd really only begun to realize the enormity of the race-fixing scam she'd described. Should I blow the whistle on them all, as Blue insisted? Would this really make me safer? I wasn't sure.

At the thought, a shudder went down my spine. What about Mac, my little unborn baby, resting so trustfully in my belly. What was best to do to protect him? My instinct shouted to say nothing, leave it alone, make no waves. But if Blue was right, that was the worst thing to do.

The only thing that was clear to me was that my overriding instinct was to take care of my baby. I grieved for Jenny, but any issues around her death and the possible injustice of it paled against the present need to protect and care for Mac. I was first and foremost, these days, a mama.

For a second I pondered what an enormous change this was. All my life I'd reacted assertively; in the past I probably would have responded to Jenny's death by wanting to avenge her in some way. I would have been determined to find out if someone murdered her and if so, to bring them to justice. Right now, I was determined to protect my baby.

Pregnancy hormones are powerful. All I could think about was how to stay safe myself in order to create and preserve a protected space for Mac.

Unfortunately, I still couldn't decide how best to do

this. Slowly, I plodded back up the hill, to be greeted by Blue holding the phone receiver out to me.

"The police," he said quietly.

The voice on the phone line was clipped and curt, of a deeper timbre than Detective Peter James's light tenor.

"Detective Edward O'Brien here," it said. "I'm from the Oakland County Sheriff's Department. In Michigan," he added. "We've been investigating allegations concerning Charles Parker and Don Chase. We think there may be some overlap in the investigation into the death of your cousin, Jennifer Parker. I've talked to the investigating officer. I'd like to ask you a few questions if you have the time."

"All right," I said, my mind racing. It was clear I was going to have to decide—and damn quick—what I was or was not going to reveal about what I knew.

"If possible, I'd like to speak to you at the crime scene."

"At Jenny's house?"

"Yes, ma'am."

"Now?"

"If possible."

I sighed. It was possible, I supposed.

"I'll be there in half an hour," I told him.

"I'll be waiting for you at the house."

Hanging up the phone, I said, "Shit," out loud.

"You're going out to talk to this cop at Jenny's place? Better have some dinner first." Blue's voice was kind but firm.

"Thanks, I will."

I munched my steak and rice in silence, absorbed in my thoughts. What should I say? Or not? Blue let me be, seeming aware, as he so often was, of my thought process and when I needed to be left alone to work things out on my own.

At last I stood up. "I'd better go. This Michigan cop will be waiting for me."

"Try to tell him what you know." Blue's tone was matter-of-fact, not asking, not ordering. He knew me better than that. "I think it would be best."

"I'll see what he knows first, if I can. If he knows some or all of it, that will make it easier."

"Take good care, Stormy. I'll be waiting for you."

And once again it was out to my truck and down the road to the Monterey Bay Ranch.

Chapter 17

THE FULL MOON WAS WELL UP over the ocean as I drove down the ranch road. Even under present circumstances, I sucked in my breath in amazement at the overwhelming quality of the scene.

Surely this spot on the cliffs above the curved edge of the Monterey Bay must be one of the loveliest places on earth. Now, dignified by the shining white orb of the round moon laying a wide, silvery trail of sparkles across the ocean water as a backdrop, the old ranch was more dramatic than ever before. Board fences glowed snowy white; wide, empty pastures were a soft dove gray; black shapes of pines threw sharper dark shadows; and the house on the cliff raised its sleek, low silhouette—all straight modern lines and shining glass—against a background of eerie blue-white light.

Slowly I bumped down the rough driveway full of potholes, trying to close my mind to the inescapable sadness of arriving at Jenny's house now that Jenny was no more.

Once again I tried to contact my cousin's spirit in my mind, get in touch with that essential Jenny-ness that was

her uniquely individual self. Nothing. No sense of my cousin's presence. No message at all.

"I'm looking at your ranch in the moonlight, Jenny," I said out loud. "I'm about to meet this detective from Michigan and I don't know what to do here. Were you pushed? Or did you jump? Or fall? What do you want me to do?"

No answer was forthcoming. Only the reassuring prod of a little fist—or foot, or knee or elbow, against the side of my belly.

No lights seemed to be on in Jenny's house, but a white sedan was parked in the drive; my headlight showed typical rental-car license-plate frames.

The man who unfolded himself out of the front seat was tall and lean, dressed in plain clothes, with curly, fair hair that looked white in the moonlight and light eyes that I imagined were blue.

"Detective O'Brien," he greeted me, flashing his open wallet in the obligatory gesture. "Sorry about the lack of light. I was told someone from the Santa Cruz County Sheriff's Department would be here to open up the house, but no one seems to have arrived."

"She left the key under the mat," I said evenly, wondering if Peter James resented this Michigan cop's arrival on the scene and was doing his best to inconvenience him.

Detective O'Brien found the key and let us both into the house. I flipped on the lights and we ran mutually appraising eyes over each other.

What I saw was a striking man—with an oddly colorless

scheme. Detective O'Brien's fair, curly hair was white-blond and sprang up off his brow in a natural pompadour. No neo-Nazi haircut here. The light eyes were blue—the palest blue I thought I'd ever seen on a human, framed by equally pale eyelashes and brows. The man's skin was white, but he didn't appear to be an albino. His features were regular and unremarkable—except for that pale cast that somehow kept me staring at him a few seconds too long.

Aware that the detective was sizing me up with equal curiosity, I tried to imagine what he saw. A middle-aged woman whose heavily pregnant belly was surely her most obvious characteristic—shoulder-length, dark hair hastily confined in an untidy ponytail, no makeup, denim over-alls (not maternity gear) that just stretched to cover her bulk. I was beyond vanity these days; it never occurred to me to wonder if I was attractive or not.

Detective O'Brien extended his hand; I shook it. Cool and bony, his handshake gave me no clue as to what I was dealing with here. His clothes were equally innocuous. Nondescript pants, shirt, and lightweight sport coat with some paperwork sticking out of the pocket.

"You're Jennifer Parker's cousin?" he asked.

"That's right. Dr. Gail McCarthy." I rarely prefaced my name with "Doctor," but I had a sudden urge to back this cop off.

"Doctor, is that right?" he said. "Are you a medical doctor?"

"A veterinarian," I said.

"Really." He looked genuinely curious for a moment; I wondered if he had animals in his private life.

"So, what am I here for?" I asked, determined to cut to the chase. I was already getting the creeps, standing here in my cousin's silent, empty house.

"As I mentioned on the phone, we're investigating some allegations regarding Charles Parker, your cousin's ex-husband, and his business partner, Don Chase. There is some question if your cousin could have been involved, and if this might have led to her death."

"Are you saying she was murdered?"

"Not necessarily. We're investigating."

I recognized this sort of cop-speak. Never tell a member of the public anything they don't need to know. I asked my next question without much hope.

"What sort of allegations are you investigating about Jenny's ex?"

The detective met my stare with his oddly pale and somehow completely unreadable eyes. "I was hoping you could tell me. Did your cousin tell you about any criminal activities that her ex-husband was engaged in?"

Now I was really going to have to decide.

"Such as?" I fenced, thinking that Detective O'Brien's eyes reminded me of my horse Gunner, with his one blue eye. When I wanted to know what Gunner was thinking, I always moved to his left side, where the brown eye was. I couldn't read his emotions at all in the blue eye.

Unfortunately Detective O'Brien had no brown eye. I found him a complete enigma as we locked gazes.

"Such as attempting to fix Thoroughbred races," he said at last.

I nodded slowly. "She did mention that," I admitted.

"What did she say?"

I took a deep breath, guessing that I was in for it now. "She said that Charley and his partner were able to fix a few races by putting the favorite out of action. She wasn't involved."

"How were they doing this?" The detective's voice was sharp; I wondered how much he knew or didn't know.

"Injecting the favorite with a leptospirosis vaccine that causes moonblindness." The detective gave a tiny sigh at this; I could see his shoulders drop a fraction and he seemed almost to relax a bit.

"Did your cousin give this information to anyone else?"

"Not that I know of," I said honestly.

"Did she make any record of it?"

"That I don't know."

I looked around the empty living room, wondering briefly if Jenny had ever confided her story on paper. The room gave back no reply; it was so generic as to appear sterile to my eyes. Large leather-covered couch and armchairs, plain wooden coffee table and end tables, TV, stereo, and the huge glass blanks of the wall of windows, with the full moon framed in the closest one. The sight of the empty deck, fluttering with crime scene tape, made me shudder and I turned away.

"Did she keep a diary, maybe in her bedroom?" The detective was pursuing it.

"I don't know," I said again, but I led the way to Jenny's room.

Once inside the door I stopped, thinking, as I had before, what an oddly ordinary room it seemed for my cousin. Cream-colored wall-to-wall carpet; pale apricot walls; plain, innocuous desk; and bed with peach-colored bedding. No statement of any kind at all except a liking for that apricot/peach color—of which I knew Jenny to be very fond. She felt it set off her hair.

Felt. Had felt. And suddenly, faced with Jenny's empty room, I remembered her last words to me, and the odd almost-smile on her face. "Don't worry. I'll be fine." That's what she'd said. And been dead within a few hours.

What did it mean? The obvious inference in light of what had actually happened was slapping me in the face. Fine. No more troubles. Resting quietly in her grave.

I stood frozen in place, replaying her words and expression, trying to decide if that was what she'd meant. Unaware of my preoccupation, Detective O'Brien stepped brusquely past me to reach Jenny's desk, his shoulder brushing mine.

At the movement I flinched, aware of how uncomfortable I felt in the presence of this man with the cold, unreadable eyes. Something in his demeanor, if not hostile exactly, seemed unpleasant to me.

He was rifling through the drawers of Jenny's desk, his back to me; I could see over his shoulders that the desk appeared to contain nothing but blank sheets of writing paper with the logo of her New Moon Ranch. Detective

O'Brien stooped to pull the lowest drawer out and the paperwork in his jacket pocket spilled out on the floor. Several sheets of paper fluttered here and there; one landed just to the right of me.

I picked it up, as basic courtesy demanded, giving it a cursory glance as the detective collected the others. A typed printout from Northwest Airlines, what passed for an airplane ticket these days, I surmised. Made out to Edward O'Brien, a flight from Detroit to San Jose.

Handing it over without comment, I watched the detective finish searching the desk and go through the bedside tables. It was already clear to me that Jenny had not kept her personal or business paperwork in the room. But if not here, then where?

Of course. "The desk in her office in the barn," I said out loud. "I think she had a diary there. I don't know what sort of things she wrote in it."

Detective O'Brien ceased searching the bedroom immediately. "Let's go see," he said evenly.

As we exited the once again dark and silent house, following the bouncing beam of the detective's flashlight toward the barn, I felt an intense creepiness. As though the moon-washed night held some menace that I couldn't fathom. The feeling was so strong it drowned out the constant twinges of grief over Jenny, and my awareness of the night noises all around me—distant boom of the surf, soft "hoo-hoo" of an owl in the pines, sudden rustle and scurry of some nocturnal creature in the bushes.

No, it was something else, something bigger, more

powerful, more harmful. All my muscles tensed as we walked step-by-step toward the hulking shape of the big barn. What? What?

My face turned, almost like a satellite dish, searching, but I could find nothing. I looked back at the detective, now a pace ahead of me, and flinched. Was it this man? This not-at-all-forthcoming cop, who seemed to push me out of his space by the very intensity of the energy that emanated from him, energy as heavy and dark as his coloring was light.

Come on, Gail, what harm is this cop going to do you, I chided myself. So what, you don't like him.

And the finest, thinnest, most delicate of little voices seemed to whisper in my mind. "Listen. How do you know he's a cop?"

Of course he's a cop; what else could he be, I rebutted sharply. He said he was a cop, he showed me his ID, he's acting like a cop.

But is he, the voice persisted. Is he really? Did you ever really see his ID? Couldn't anyone call you up and say he was a cop, hold up his driver's license as if it were some sort of ID, assume that I'm-in-charge-here cop manner. Once he knew that you knew about the racehorse scam, he never asked one more question, just started looking for any more evidence Jenny might have left. All you really know is that his name is Edward O'Brien and he flew from Detroit to San Jose on Northwest Airlines.

At the words, a jolt went through me. I was still walking steadily across Jenny's barnyard, half a pace behind the

detective, not really needing the light of his flashlight in the chilly brilliance of the full moon, when I remembered something. One small detail I'd completely forgotten, had never considered important until this moment.

Charley's vet, the one who had produced the lepto vaccine, Jenny had said his name was Ted. She had never, that I could recall, said whether or not he'd gone on to be involved in the scam, but what was more logical than to assume that he had. What had Jenny said? "He'd been known to help fix a race." Something like that. What if he'd begun the scheme with Charley and Don, and kept working with them ever since? And what was Ted but a nickname for Edward?

And suddenly Charley's protests to Jenny that it wasn't safe for her to be here took on a possible new meaning. Charley really might have been trying to protect Jenny. Maybe he was afraid that Ted would want to silence her forever.

My eyes swiveled sharply to the human form beside me, just now sliding open the door at the end of the barn breezeway. I had no real evidence for all this; it was no doubt far-fetched, but my skin prickled in primitive, atavistic dread. Something in the air was skewed, fractured, inherently full of menace. Something wasn't right. I knew I was in danger here and somehow I felt absolutely sure that this man was a threat.

The door slid open; the lights clicked on. I met Edward O'Brien's eyes hoping desperately that the sudden terror I felt wouldn't show.

"Her office is right over here," I said, as calmly as I could manage.

He made no reply, just stepped quickly through the door I'd indicated and fumbled for the light switch.

Should I run? A second's thought made the answer obvious. I hadn't a prayer. I couldn't outrun a toddler in my present state. I'd never get far enough to hide before he caught me.

I should just act as if I had no suspicions at all, I told myself; maybe he'll let me go.

Unlikely, if he really was Ted the vet. Not now that he knew I knew. He would need to silence me,

My heart pounded fiercely in my chest. As he'd silenced Jenny? How could I know? I didn't even know for sure that he was Ted the vet. Maybe he really was Detective Edward O'Brien.

I didn't think so. Watching the hasty way he was thumbing through Jenny's diary, I thought he looked far more like a criminal desperate to cover his tracks than a cop methodically investigating a crime.

What to do? I rested my hands on my belly in the doorway of Jenny's office and thought fiercely. What could I do to protect myself and Mac?

I had no weapon of any kind; my cell phone was in my truck, attached to the carger. I had not thought it necessary to protect myself from a cop; it had never occurred to me that anyone could call me up and say he was a detective; anyone could hold up the driver's license in his wallet in the dark as though it were a cop's ID. It had never crossed my mind that I ought to check.

And the total lack of other cops, the insistence on interviewing me out here? Not once had I questioned the oddness of it all.

Which left me alone in an empty barn with a man who might possibly want to kill me. Quite possibly.

My heart raced and thudded away in rapid, shuddering beats; I urged myself to think, to no avail. O'Brien was reading a section of Jenny's diary intently; a horse neighed loudly down the aisle, reminding me that I wasn't in an empty barn—the place was full of horses.

The shrill neigh rang out again. One of the stallions, I realized—the three of them were stabled right down the barn aisle from this office. My eyes roved desperately, seeking a solution.

I could walk off down the aisle as if I were looking at horses. He didn't know I was suspicious of him; he might let me go, absorbed as he was in his task. If I reached the other end of the barn I could let myself out the door; Juan's house was a mere hundred yards or so away. I might make it.

But if I once let him see I suspected him and was trying to get away, he would never give me another chance. My gut tightened like a fist. He'd put a stop to me right then.

I needed, somehow, to incapacitate him.

Hit him over the head with something heavy. I looked frantically down the barn aisle; the place was just too goddamn neat. No handy shovels anywhere—all carefully put away where they belonged.

The office didn't look any more promising. I couldn't see any paperweights, or better yet, stray hammers. No-

thing that looked like it would do instant and major damage.

And then it hit me. I couldn't bash this guy over the head and try to kill him on the chance that he was Ted the vet. What if he really was Detective Edward O'Brien?

And I simply dared not ask any leading questions. If he was Ted the vet and he thought I suspected, he was bound to silence me fast.

What in hell could I do? Please, I prayed silently to all the spirits who might help me. Please. Tell me what to do.

"I need to go to the bathroom. Excuse me," was what came out of my mouth. It was true enough, but I hadn't planned to say it.

Without looking at O'Brien, I walked past him and into Jenny's box stall bathroom. Pulling the sliding door almost shut, I left a one-inch crack. Immediately I turned the water on in the sink, like any excessively modest woman would, and stepped back into the middle of the room, where I could see through the crack.

I'd been careful to leave the light out; I knew O'Brien could not see in. As I watched he looked up from the diary, ascertaining that I was in the bathroom and apparently engaged, then quickly pulled a syringe with an attached needle out of his jacket pocket, also a bottle of clear fluid, wrapped in a ubiquitous medical label.

Quickly, competently, not a motion wasted, the long, pale fingers pulled the cap off the needle, pushed the needle through the cap of the bottle, turned the bottle upside down and injected some air bubbles, then proceeded to

fill the syringe. It only took half a minute; I didn't need to see more.

I looked across the room. As I'd remembered, a small door with a latch led to the stall next door, the home, if I remembered correctly, of the well-mannered gray stallion named Rocky. Turning back quickly, I flushed the toilet, hoping the noise would cover the sound of the latch sliding back. I was going to take my chances with Rocky.

Chapter 18

OPENING THE ESCAPE DOOR and ducking through it, I latched it quietly behind me before I even thought to look for the horse. There he was, his gray coat chalky white in the light that filtered in from the barn aisle, standing in the other corner of the stall, his ears pricked sharply forward, clearly startled at the sudden and probably unprecedented appearance of a human in his space. Humans had no doubt previously walked in a normal fashion through the stall door.

"It's okay," I whispered, afraid to raise my voice. "It's okay."

Rocky seemed to relax marginally; I hoped Jenny's account of him as well-mannered was truthful. I was no experienced stallion handler. But I was a good deal less afraid of Rocky than of those hands filling that syringe I'd just seen. As an image of evil personified, it was indelibly printed on my mind.

I only had a minute here. O'Brien would realize shortly that I'd disappeared and there was only one place I could have gone. He'd also realize I suspected him. I had to do

something fast. Moving past the softly snorting horse, I slid the stall door bolts open as quietly as I could and looked out in the aisle.

Empty as before. The faint hope that Juan had seen lights on in the barn and come to investigate died an instant death. Shit. I took a step out and bumped my shoulder on a fire extinguisher. A fire extinguisher.

In a moment I had jerked it free and stepped back in the stall, sliding the latch closed behind me. Wedging myself in the nearest corner, I gripped the handle of the extinguisher in both hands. I felt Rocky nudge my elbow with his nose and prayed that he was trustworthy. I couldn't turn to face him; I couldn't deal with him. I was watching the escape door.

Mac moved inside me and I prayed with all my might that I wouldn't fail us. Let me take care of this baby, I begged—just let me protect this child. Let him come to no harm.

I was aware of the barn, quiet except for the rustle and stamp of the horses in their stalls; I could feel the soft whisper of a draft on my skin. Every fiber of my being was attuned to the sounds in the bathroom next to me.

Just the soft purr of the filling toilet tank for a while. Then silence. The occasional creak of a board, which I took to be O'Brien still searching Jenny's desk and diary. And then, suddenly, a different sort of silence. A sharp, alert silence. I could almost feel him listening.

Then O'Brien's voice, calm, not threatening. "Dr. McCarthy?"

Right, I thought. He's wondering, but he isn't sure. I had the edge on him now. I was sure. The sight of that syringe and needle was more than enough for me. No earthly reason for a cop to be filling a syringe. But I could think of a reason, and several deadly substances, that Ted the vet might have. And I was one hundred percent sure I didn't want to take the chance that I might survive that injection.

"Dr. McCarthy." More insistent.

And then the creak of boards and a knock, which I took to be on the bathroom door. "Dr. McCarthy!"

I pressed my back to the wall of the stall and shivered, both with cold and fear. Rocky stood quietly next to me; he'd given up on getting my attention apparently, and seemed to be as gentle and well-mannered as Jenny had indicated.

Suddenly the slam of the sliding door pushed open, and a sharp and violent "Damn."

O'Brien had discovered my disappearance. Would he come through the escape door? I waited, gripping the fire extinguisher firmly. He must see the door; he must know that was how I'd exited the bathroom.

A second's pause and then rapid footfalls. The escape door remained shut. My heart hammered frantically in my chest. At a guess, O'Brien was dashing out of the office into the barn aisle.

I imagined him searching, finding the aisle empty. Soft, barely audible footsteps just outside the stall door. Then the click of the latch being pushed back. The door slowly opened a crack. Light spilled in.

Wedging myself in the corner, I tightened my grip. Help me now. Let me do what I need to do.

Rocky snorted and walked forward toward this new human's entrance, as I'd hoped he'd do. I had a second. And in that second, O'Brien stepped through the stall door, his hand holding the syringe held at the ready, his gaze drawn automatically to the motion of the horse. Now.

I shoved the canister straight at his face and pulled the trigger. Even as he turned toward me in surprise, brandishing his needle, the white foam shot out, spattering his face, covering his eyes, nose, and mouth, knocking him back against the shoulder of the startled horse. One hand swiping at the froth, he lunged toward me, thrusting with the syringe, desperate to connect.

I kept squirting, sidestepping his outstretched arm, aiming for his eyes. Blind him, blind him — the words echoed in my head, as I watched his face disappear in white foam, heard him choking and gasping for air.

In the next second Rocky's hip bumped me sideways and I dropped the canister. Frightened by the commotion, the stallion whirled sharply, knocking the staggering man to the ground. Seeing the open stall door, the horse charged out into the barn aisle.

I could hear the other stallions neighing loudly as I dashed out the door after Rocky. Please, God, let that bastard be out for the count, I prayed, lumbering down the aisle as fast as I could, aiming for the door at the far end, hoping I could make it to Juan's house before O'Brien recovered.

I'd reckoned without the desperation that drove the man. Looking over my shoulder, as I trailed the flying form of Rocky down the aisle, I saw a human figure stumble through the stall door, face still covered with foam, coughing and retching, but pursuing. With a gun in his hand.

Oh shit. A gun. He didn't have to get close to me with a gun. Clearly O'Brien had given up whatever scheme he had to make my death look accidental. He just wanted to silence me, once and for all.

His free hand swiped fiercely at his eyes; if he could see he was going to shoot me. Shit. What to do?

The pounding of hooves made me step hastily back against the wall; Rocky flew back by me at the gallop, neighing to the other two stallions, who, wildly excited by all the action, were crashing around in their stalls, screaming, rearing, and kicking the walls.

Now Rocky was between me and O'Brien. I had a second or two. And in those few seconds I knew what to do. Running forward, I reached the door to Trouble's stall. In one quick motion I threw back the latches and pulled the stall door open, hiding behind it as the stallion burst out like a ball of fire and launched himself, as I'd hoped, in the direction of Rocky.

As fast as I could, I lumbered down the barn aisle in a clumsy run until I reached Gator's stall. Looking back over my shoulder I could see Trouble and Rocky filling the aisle between me and O'Brien, could hear Rocky squeal and then strike out with a front hoof as Trouble

reared, reaching out to grab the older horse by the crest of the neck.

I couldn't see O'Brien at all; then for a moment I glimpsed him behind the horses—in the next second the world seemed to explode.

Ka-boom! The shot echoed off the barn walls and deafened my ears. I flattened myself against the stall door, my heart pounding. Was I hit? Was I okay?

In another moment my body asserted its wholeness; he hadn't hit me, then. I could hear the frantic stallion in the stall beside me screaming with excitement and adrenaline. Pulling the latch back, I let him out.

Gator crashed through the open doorway like a rocket launch. Tail high, he aimed himself at the charging mass of Rocky and Trouble, now running straight at us, frightened, no doubt, by the detonation of the pistol. I couldn't see O'Brien at all for the horseflesh between us.

The three studs met in the middle of the aisle; in a second it was apparent that Trouble and Gator meant business. They'd stared and shouted at each other from a distance for too long, each anxious to prove to the other that he was the dominant horse. Now that the opportunity had finally presented itself, they clearly meant to do battle and settle the matter once and for all.

While Rocky moved on the periphery, occasionally squealing, striking, or biting, Trouble and Gator closed right in, rearing straight up in the air, heads weaving like striking snakes, teeth bared as they lunged at each other, both stallions determined to connect and do damage.

For a frozen second I stared at this melee. There were the screaming, fighting horses; I had a brief glimpse of O'Brien trying to push between Trouble and the wall, and then, in a moment that happened so quickly it was hard for it to register, Trouble's head snaked out and grabbed the man by the shoulder, picked him up bodily, and threw him against the wall. I saw the back of O'Brien's head snap hard against a post with an audible crack.

Even as his body slumped downward I could see he was out. Dead or alive, I didn't know, but not moving for the moment, anyway. Stallions are incredibly strong; it was possible that Trouble had broken O'Brien's neck.

I found I didn't care. I did care, however, to rescue the three horses that I'd used to engineer my escape. Turning, I ran heavily down the barn aisle to the door. Without looking back, I pulled it open and slid it shut behind me, then ran as fast as I could to Juan's house.

"Help!" I shouted as I banged on the foreman's door. "Help! I need help!"

Chapter 19

IT TOOK A MINUTE FOR JUAN to register who I was and to grasp the gist of my story; he finally seemed to pick up on the frantic urgency in my tone, and the words "the stallions are loose" grabbed his instant attention.

As he started out the door, I demanded, "Do you have a gun?"

His "Yes. Why?" was confused.

"There's a man with a gun in the barn," I said. "He tried to kill me. He's still there."

"*Ai.*" Juan turned and reappeared in a minute with some sort of large-caliber pistol.

And then we both charged in the direction of the stallion barn, me trailing a good distance behind the fast-moving foreman. We could hear the screams of the horses through the darkness and Juan's face was a mask of dismay as he turned to face me in the moonlight.

"Be careful of the man," I warned as he slid the door open.

We both stared through the gap. If anything, the scene was wilder than ever. I could see nothing but the twisting,

weaving bodies of the two darker stallions, engaged in full combat in the aisle before us. The paler shape of Rocky was visible behind them; I couldn't see O'Brien at all.

In the barn lights, bright red blood showed clearly on all three horses; it was hard to tell how badly they were injured in all the pandemonium.

The sight of those hundreds of thousands of dollars' worth of horseflesh bloodied, and in the midst of damaging each other further, galvanized Juan. *"Chingadera"* burst out of his mouth; he launched himself at the nearest stall door, which proved to be the equipment shed, shoving the pistol at me.

I grabbed it. In a second Juan reappeared, brandishing a broom. Ignoring my "Watch out for the man," he strode toward the fighting stallions, determination clear in his stance and authority plain in his voice. "Enough, that's enough, now."

For a second I wondered what in hell I was supposed to do here. I still couldn't see O'Brien; I wasn't game to approach the fighting horses. And then the obvious occurred to me.

"Your cell phone!" I shouted at Juan.

He paused, reached in his pocket, and flipped the small, shiny object backhanded in my direction. It landed in the dust of the barn aisle; I scrambled to pick it up.

Stepping back behind the barn door, I dialed a number I hadn't used in a year, thanking God I had a good memory for numbers, and phone numbers in particular. Let her answer, I begged.

She did. "Jeri Ward here." Crisp, authoritative, her cop voice.

"Jeri, it's Gail. Gail McCarthy." I knew I sounded breathless and desperate; I didn't care. "I'm at my cousin's, Jennifer Parker's; there's a man here with a gun. Can you come?"

"I'm on call tonight. I'll be right there. Give me the address."

I repeated it, and hung up in relief. It was a measure of our long relationship that Jeri Ward had not questioned me further. There was a basic trust between us that had grown over the years; I'd called her because I knew I could work with her.

One glance into the barn made me cringe. Juan had succeeded in separating the two dark stallions, mostly by dint of whacking them in the face with the broom. The horses were furious, bloody, and over the top with adrenaline; Juan was literally fencing with Trouble, whose head kept snaking toward this pesky human that was attempting to get in the way of the equine battle. Judging by the velocity of Trouble's strikes, Juan's broom wasn't going to last long.

I forgot about O'Brien, I forgot about everything but the need to somehow restrain the belligerent Trouble before he did any more damage to himself or others. Reaching into the equipment shed next to me, I grabbed a large, square shovel in my free hand, raised it over my head, and with the loudest roar I could manage, charged right at the surprised horses.

Whether it was the suddenness of my attack, or the fact that Juan had already distracted them, I wasn't sure, but the stallions turned and ran. To my absolute joy, they all seemed to be sound. Even better, Gator ducked back into his open stall; perhaps he'd had enough of Trouble.

I handed Juan the shovel, and with it in one hand and the broom in the other, he began herding Trouble toward his own stall.

I could see O'Brien now, still lying on his side in the barn aisle, apparently unconscious; Rocky paced back and forth near him, not interested in the fallen man, but clearly upset by Trouble, who was crashing in his direction.

For a second I thought Trouble would attack the already-bloody Rocky, but the older stud pinned his ears and swiveled his butt-end toward the other horse, prepared to lash out, and Trouble thought better of it and whirled back through his open stall door. Juan slammed it shut behind him.

This left Rocky—and O'Brien. Juan ignored the man; every bit of the foreman's attention was focused on getting his charges safely back in their stalls. Soothingly, he approached Rocky, "Come on, now, you, time to go back in."

I still held the pistol; it fell to me to cover the fallen O'Brien. I could see the metallic sheen of his own pistol in the dirt of the barn aisle, next to his open right hand.

Gingerly, I approached him, training Juan's gun right at the center of O'Brien's body, watching him for the slightest motion or sound. Smears of white foam still

showed on his jaw and brow; I could see where blood had soaked through the torn fabric of his blue shirt, the mark of Trouble's teeth.

And then he moved. I stepped back hastily, as he muttered and moaned, reaching out with his hand in the direction of his gun, half raising himself to his knees.

Now, Gail, do it now. Don't wait. Now.

The voice was insistent, urging me, demanding. Now. Now. *Now.*

My finger tightened on the trigger of the pistol, as I trained the gun on his swaying torso. Now. Taking a short step forward, I kicked O'Brien's pistol hard, moving it three feet away from him, praying it wouldn't go off.

It didn't. Keeping my eyes locked on him as he turned slowly to face me, I said, as clearly as I could enunciate, "Hold perfectly still. If you don't, I will shoot you."

O'Brien didn't seem to get it. Squinting at me as if he still couldn't see well, he reached again in the direction of his pistol.

I raised my gun. "I will kill you," I said levelly, "if you move again. You killed Jenny."

I meant it, and he must have heard it in my voice, because he stopped moving and just stared at me, still on hands and knees.

A long second of silence. Motion behind me proved to be Juan, stepping up to my shoulder.

Ted O'Brien looked at us and coughed. "I didn't," he said, "kill Jenny."

Chapter 20

"YOU DID," I ASSERTED. "You bastard. Am I supposed to believe it's a coincidence; she jumped off her deck and you just happen to be out here, and then try to kill me? She knew about your dirty scheme and you wanted to get rid of her. You were going to kill me because she told me."

O'Brien coughed again and wiped his mouth. "I didn't kill her," he said heavily, "and I didn't try to kill you."

"What? You unmitigated bastard!" I had the brief impulse to shoot him then and there. "You tried to kill me right here in this barn."

Still on hands and knees, head half-hanging, O'Brien took a deep breath. "I shot to frighten the horses; I was afraid they would hurt me."

"What about that damn syringe?" I was shaking with delayed shock and anger.

"Torbugesic," he grunted. "I thought the gray stud horse had a bellyache. He belongs to some friends of mine; I'm a vet, you know."

"I know who you are." Jesus. This I had not expected.

O'Brien meant to deny everything. Torbugesic would, indeed, sedate a colicked horse and potentially relax him enough to get rid of the colicky cramps. It was a medication I'd used myself, many times before, for a similar purpose. But a horse-sized dose of Torbugesic would put a human out cold. And I would not like to guess what O'Brien had meant to do with my inert body. Pitch it off Jenny's deck, probably.

"My God." I stared at the man in disbelief. Could he get away with this? Surely not.

"You bastard," I said again. Inadequate as it was, I seemed incapable of any other reaction. "I know what you were here for."

Blurry-eyed, bloody, and half-down in the dirt of the barn aisle as he was, Ted O'Brien's cold blue eyes still showed a hard, calculating edge as he stared back at me; I was grateful for Juan's presence. I had the sense that O'Brien was still struggling to turn the situation in his favor, that he was game for one more try at eliminating me, if he could find a way to do it.

Even as the thought crossed my mind, the barn door slid open to reveal Jeri Ward, who gazed at our little tableau and trained her drawn pistol on O'Brien. "Detective Ward, here, Santa Cruz County Sheriff's Department," she said sharply. "Drop your weapons."

I was the only one holding a weapon, so I lowered it. "His gun is a few feet from his right hand," I said quietly.

Jeri met my eyes, jerked her chin in an affirmative, and stepped forward, covering O'Brien with her own gun. In

an effective minute, O'Brien's hands were cuffed, Jeri
moving adroitly. The man made no move to resist; his
eyes never left my face.

I kept my own eyes on his and spoke levelly. "Jeri, I
have a story to tell you and I want this man to hear me tell
it."

Jeri hesitated a moment, and I added quickly, "Right
now. It will take five minutes."

Once again it was a feature of the trust that had grown
up between us over the years, which turned her automatic
protest into an assent.

"Go on," she said. "You have five minutes."

I recounted the moonblindness scam as Jenny had told
it to me; I thought I saw the tiniest wince in Ted O'Brien's
eyes as I named him, Charley Parker, and Don Chase
quite clearly and described, as well as I knew, the tracks
where they had been running horses and the place where
Charley trained. Jeri had heard of Jenny's death and the
subsequent investigation; speaking as calmly as I could
manage I went over this evening's events beginning with
the phone call from "Detective O'Brien" and ending with
the moment before Jeri herself walked through the barn
door.

"He means to deny all this," I finished, "but I'll swear
on a stack of Bibles that's how it happened. And as for
you," I added directly to Ted O'Brien, though my eyes had
seldom wavered from his as I spoke, "I want you to know
that I will tell every cop I speak to every detail of your
damn crooked scam; my husband already knows it, and

none of you has anything to gain by trying to silence me now."

No response that I could discern.

I turned back to Jeri. "That's all," I told her.

"You'll be asked to make a statement," she said evenly.

"I know. I will. Right now I need to get Juan some help to doctor a few horses and then I need to go home." I patted my belly. "All right?"

"No problem, Gail." Jeri gave me her brief cop smile.

Even as I called the long-suffering Lucy on Juan's cell phone, I could hear Jeri reading O'Brien his rights. I didn't look at him now, but I could feel his eyes on me.

Nothing more I can do, I told myself. I've done what I can. Time to let go of it.

And, "I've got some horses that need doctoring," I told Lucy. "Not very easy patients, I'm afraid. Bring lots of tranquilizers."

Chapter 21

TWO DAYS LATER, BLUE AND I listened to a poised Jeri Ward inform us that Ted O'Brien was sticking to his story. The cops had found no evidence that Jenny was murdered. The autopsy had shown no drugs in her system; they could find no fingerprints or any sign of foul play.

O'Brien denied that he'd posed as a detective; he insisted that he'd come to California to look at a horse that was for sale at Jenny's lay-up farm. He continued to maintain that the syringe, which was found in Rocky's stall and did indeed contain four cc's of Torbugesic, was intended for the gray stud horse, to ease a colic. He stated that I'd attacked him with the fire extinguisher for no good reason, and then turned the stallions loose, putting his life in danger. He'd fired the pistol up in the air, he asserted, to scare the horses away, as he was afraid they'd harm him.

"Now I know he's lying," Jeri said, her neatly coifed blond head poised as calmly as ever over her tidy steel gray suit. "But it's going to be damn hard to prove. I guess you didn't take to Pete James, Gail, but he's a good cop, and he's working really hard on this. But he's not getting

anywhere with the allegations of fixing races back in Michigan, and this guy Ted O'Brien is sticking to his story like it was glued to him. It's frustrating."

Blue, sitting next to me, put an arm around my shoulders. "Do you think Gail's in danger from these people?"

"No." Jeri was clear. "You did the right thing, Gail, speaking out in front of him. I can't see why they'd take the risk of trying to harm you now. That would only make your story appear to have more validity."

I shook my head. "I just can't believe it. The guy can deny everything and get away with it."

"So far," Jeri said grimly. "We're still working on it. Were those stallions okay?" she added. Jeri had a horse of her own that she was very fond of.

"Yeah, they're fine. Superficial stuff, that's all. I'm really glad. I'd have felt very badly if they were seriously hurt, but in the moment, well, you do what you have to do to survive."

I placed my hands over my belly as I felt Mac shift slightly, like butterfly wings fluttering, and Blue's arm on my shoulders tightened gently. "You did good, Stormy," he said firmly. "Real good. You saved yourself and Mac, too. You did the right thing."

"I agree," Jeri said, and stood up to leave. "Thanks for the coffee," she added and then smiled at me. "When's the big date?"

"April thirtieth," I told her.

To my surprise, she suddenly reached out and gave me a hug. "Congrats in advance, Mama," she said.

Epilogue

McCARTHY WINTER WAS BORN May first at ten P.M., a healthy seven-pound, five-ounce baby boy, following twelve memorable hours of labor. I rejoice every day in his life and health, even as I grieve over Jenny's death and my failure to help her. Joy and sorrow intertwined, just as the madonna promised.

I never heard from Charley Parker, Don Chase, or Ted O'Brien again. O'Brien's case remains in limbo. He continues to assert he had nothing to do with Jenny's death and never meant to harm me. The police, as Jeri puts it, continue to investigate, but so far with no result. I still don't know for sure if Jenny jumped or was pushed off her deck; perhaps I never will.

My Danny horse seems to be doing reasonably well, despite his odd condition; I was able to lease a ten-acre pasture from my neighbor, and turned Twister and Danny out together. They both look content, grazing in the sunshine.

As for Pan, he still stands on the table next to our bed, facing the east window, playing his pipes to the dawn.

Andy Snow

ABOUT THE AUTHOR

Laura Crum (pictured with Plumber), a fourth-generation Santa Cruz County resident, has owned and trained horses for over thirty years. She lives and gardens in the hills near California's Monterey Bay with her husband, son, and a large menagerie of horses, dogs, cats, and chickens. She may be e-mailed and visited at www.lauracrum.com.

MORE MYSTERIES
FROM PERSEVERANCE PRESS
💀 *For the New Golden Age* 💀

JON L. BREEN
Eye of God
ISBN 1-880284-89-8

TAFFY CANNON
ROXANNE PRESCOTT SERIES
Guns and Roses
Agatha and Macavity Award nominee, Best Novel
ISBN 1-880284-34-0

Blood Matters
(forthcoming)

Open Season on Lawyers
ISBN 1-880284-51-0

Paradise Lost
ISBN 1-880284-80-4

LAURA CRUM
GAIL MCCARTHY SERIES
Moonblind
ISBN 1-880284-90-1

JEANNE M. DAMS
HILDA JOHANSSON SERIES
Crimson Snow
ISBN 1-880284-79-0

KATHY LYNN EMERSON
LADY APPLETON SERIES
Face Down Below the Banqueting House
ISBN 1-880284-71-5

Face Down Beside St. Anne's Well
ISBN 1-880284-82-0

ELAINE FLINN
MOLLY DOYLE SERIES
Deadly Vintage
(forthcoming)

HAL GLATZER
KATY GREEN SERIES
Too Dead To Swing
ISBN 1-880284-53-7

A Fugue in Hell's Kitchen
ISBN 1-880284-70-7

The Last Full Measure
ISBN 1-880284-84-7

PATRICIA GUIVER
DELILAH DOOLITTLE PET DETECTIVE SERIES
The Beastly Bloodline
ISBN 1-880284-69-3

The Scarpered Sea Lion
(forthcoming)

NANCY BAKER JACOBS
Flash Point
ISBN 1-880284-56-1

JANET LAPIERRE
PORT SILVA SERIES
Baby Mine
ISBN 1-880284-32-4

Keepers
Shamus Award nominee, Best Paperback Original
ISBN 1-880284-44-8

Death Duties
ISBN 1-880284-74-X

Family Business
ISBN 1-880284-85-5

VALERIE S. MALMONT
TORI MIRACLE SERIES
Death, Bones, and Stately Homes
ISBN 1-880284-65-0

DENISE OSBORNE
FENG SHUI SERIES
Evil Intentions
ISBN 1-880284-77-4

LEV RAPHAEL
NICK HOFFMAN SERIES
Tropic of Murder
ISBN 1-880284-68-5

Hot Rocks
(forthcoming)

LORA ROBERTS
BRIDGET MONTROSE SERIES
Another Fine Mess
ISBN 1-880284-54-5

SHERLOCK HOLMES SERIES
The Affair of the Incognito Tenant
ISBN 1-880284-67-7

REBECCA ROTHENBERG
BOTANICAL SERIES
The Tumbleweed Murders
(completed by Taffy Cannon)
ISBN 1-880284-43-X

SHELLEY SINGER
JAKE SAMSON & ROSIE VICENTE SERIES
Royal Flush
ISBN 1-880284-33-2

NANCY TESLER
BIOFEEDBACK SERIES
Slippery Slopes and Other Deadly Things
ISBN 1-880284-58-8

PENNY WARNER
CONNOR WESTPHAL SERIES
Blind Side
ISBN 1-880284-42-1

Silence Is Golden
ISBN 1-880284-66-9

ERIC WRIGHT
JOE BARLEY SERIES
The Kidnapping of Rosie Dawn
Barry Award, Best Paperback Original. Edgar, Ellis, and Anthony Award nominee
ISBN 1-880284-40-5

REFERENCE/ MYSTERY WRITING

CAROLYN WHEAT
How To Write Killer Fiction: The Funhouse of Mystery & the Roller Coaster of Suspense
ISBN 1-880284-62-6

**Available from your local bookstore or from
Perseverance Press/John Daniel & Co. at (800) 662-8351
or www.danielpublishing.com/perseverance.**